Tales from the

Sea of Thieves

Tales from the

Sea of Thieves

Recorded and Compiled by

CAPTAIN FLAMEHEART

And Diving Bel!

wiv Half-a-Stew Jean

'and Nine Cat Nura

TO THE SEA...

My name is not important, for I shall be leaving it behind at first light along with the rest of my possessions.

This is my voice, these are my words.

I have lived a very charmed life. No boy could have wished for a happier childhood, nor enjoyed a finer education, upon which I have built a very good life. For as far as I can remember, my father was there for me; guiding me, and... guarding me.

Now my father is no longer alive, I would love to become the man that he was. This is not possible, however. We are not family, for one thing. I was rescued soon after I was born, although from what is a secret that papa took to his grave.

"You do not need to know."

I feel, now that he is gone, I am no longer chained by my upbringing. Society expects me never to do anything beyond studying and safe, studious work. But I must do something with my life, to live up to his memory. To live up to my own ambitions. I cannot resist the call any longer.

Father was a pirate, and his tales told of nights atop the endless oceans, days spent on golden sands with a sword in one hand and a tankard in the other, and scores of legends bearing his name. Upon his return, he would sit me upon his knee and regale me with his adventures, igniting a burning desire within my chest to see these places for myself. Having travelled full circle in every possible direction, Father eventually settled down on this magnificent estate, in which a small candlelit corner of the most private room I now write.

Tomorrow I will not be here.

I have arranged to vanish over the horizon to retrieve myself.

LOST AND FOUND

As a scholar, I can hold conversations better than I can hold my drink, but it has become my ambition to leave that life behind me; to rid myself of paper shackles and embrace the life of a pirate on the Sea of Thieves.

The promise of that azure horizon contains everything my life does not; the thrill of adventure, the challenge of self-sufficiency and the purest thrill that freedom, true freedom, sparks in the soul. Still, those who know me would assume that I had lost my mind, and may just as well consider plans to visit the moon. This isn't madness. I can assure you that to me it feels precisely the opposite; by far the most grounded decision I have ever made.

After all, between the study of literature, multiple languages, fine art, mathematics and philosophy, Father insisted that I became a strong swimmer and an adept swordsman. Navigation too: I can follow any old map, guided by a compass and mariner's spyglass. Although my off-shore experience has been limited to a small keel boat, I have confidence that so much theoretical knowledge shouldn't take long to adapt to something practical.

My father's stories have become my obsession, which is how anyone might look at it from the outside. But you should know that there is more to this than proving myself. Only when the whole world lies before you, across the glittering blue, can you see what you are truly made of. Which is why this voyage, my mission, is about finding the man that exists on the inside. My inner pirate.

Ah, the life of a pirate! Who would want anything else?

THE PIRATE IN ME

Whenever I have witnessed pirates coming and going down at the harbour, young or old, male or female, there's something about how they are with each other that stirs my soul. There is something hidden behind their eyes, and resounds through their fearless voices.

They carry themselves so naturally, unashamed... defiant you could say, with social standing based purely on reputation. "What will my legend be?" I once asked myself as a teenager, setting down a heavy stack of books by the quayside to rest halfway home from the library. Bookworm extraordinaire? A medal for politeness at dinner? The Professor of small-talk?

My heart flew instantly to these people; I felt I had little choice but to follow. And I feel now exactly as I did then, surprised by the swell in my eyes and the smouldering inside my chest.

My father's name was feared across the waves and as his son, it is a mantle I have chosen to inherit to complete my transformation. Thus, I will instruct the crew to call me... Captain Flameheart! Perhaps, once word of my deeds have spread, some will think my father has returned from the grave!

Hah! There is no way his crew called him THAT. Faintheart, maybe.

Depends how much he was paying them.

You can call a minnow a shark but that doesn't give it teeth.

Papa, if somewhere you can still hear my thoughts I pray that you understand. Your wealth branded me a scholar, but your legacy birthed the pirate in me.

CHOOSING A SHIP: INTRODUCTION

One is no more a pirate than a pelican if without a ship. I have made it my first order of business to inspect, after handsomely compensating the owners, many fine vessels at the oceanfront. My guides have been everyone from the wizened old men to tattoo-laden young women, and more often than not warily observed by the ships' hands. These ships, I have learned, never truly rest.

Initially while on deck, I did feel unnervingly like an actor treading the boards of a stage, working a largely disapproving audience. On some occasions I'm sure that greater crowds came to see me bang my head than have gathered to endure a tired old theatre in town.

It may have been my imagination, helped along by some of the complimentary spirits, but I couldn't help notice how ships often resemble their owner or vice versa. Elegantly simple ships for those who favour practical garb in muted colours; outlandish figureheads and ornately carved accoutrements for pirates who themselves are swathed in scarves, rings and other finery. Upon drifting asleep in a haze one evening, privately amused at my observations, I became quite emotional after realising this relationship was something that I desperately sought.

Haha! Well I suppose this is in some ways true but I wouldnt want to be the lad telling me I look like an old ship unless I was you know asking to lose an eye and most of my teeth

SAFE AND SECURE: SHIPBUILDING

For my own ship, it seems the most sensible route would be to consult with the owners of local ship building firms, although not demonstrating commitment at this stage. Although, I am already convinced, after touring some of the more exotic examples at bay, that true pirates would never adopt such a rudimentary approach at such terrific expense. They must surely have 'inherited' their livelihood and all means to pursue it, both craft and crew.

Feeling no desire to have my voyage sabotaged by a decision born of ignorance, I laid my intentions bare to the shipwrights I visited. While no-one I spoke to would acknowledge the Sea of Thieves by name, a few did admit that they knew of young apprentices who'd brazenly undertaken the voyage I planned for myself.

Ha!

Really? You went through this man's entire diary doing this? Honestly Bet, do you always need to have the last word?

Astonished that a youth of limited means could afford to make such a journey, I enquired further, and it was here I first gleaned what should have been obvious all along. Businesses, trading companies, privateers... they see the Sea of Thieves as a rich vein to be mined, its riches and secrets plundered, its denizens transformed into loyal customers.

You mean like this?

How simple to ply an impressionable apprentice from their master and send them forth not just as an employee, but an envoy. I began to understand why those who sail the Sea of Thieves wish to keep it such a closely-guarded secret. Somehow, this insight has only hardened my resolve.

Good lad Faintheart. Much respect to you.

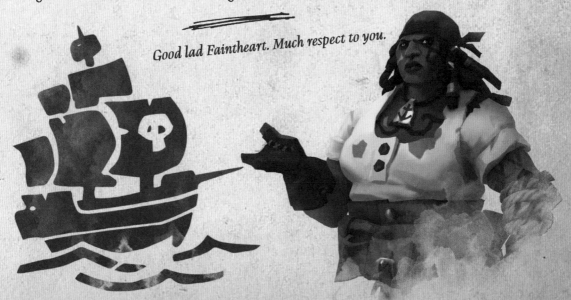

SEEKING OUT PIRATES

I must admit that it has taken me several months to feel at ease with the pirates
that visit our taverns or linger on the outskirts of town. Formal introductions
did not serve me at all well, my groomed appearance raising suspicion even
before my educated vocabulary and carefully enunciated intents were laid bare.
Politeness does not equate to showing respect when it comes to a group that,
on the whole, assumes that all are considered equal. It is our ideas, strength of
conviction and charisma which determine the leaders from followers.

I had to leave my heritage behind, taking only my soul to bear at the drinking
table. I must say that this has been the hardest research that anyone can
undertake, akin to the longest game of '21' imaginable. Fortune dealt me a very
strong hand in life in terms of financial security and moral upbringing, but
ultimately it was my true worth that was being judged by these pirates. This is
the person that you will only find reflected in the bottom of a glass at 5am,
in the last wakeful compartment of your brain, that speaks from the bottom
of the heart.

It was to this person, the real man, that the hardiest of seafarers finally shared
their tales of how they and their ships first met. Each became more improbable
than the last, such as the tale of the fellow who 'won' his ship during a bet with
its original owner; a swimming race to a nearby island. While the captain was
thus distracted, his crew were rounded up and his vessel seized by the time he
returned, soggy and triumphant, if only momentarily.

This last story was authenticated by the cackle of a man whose name I politely asked, but received only the darkest of one-eyed glares in response. I later felt better about the offhand dismissal after hearing his name banded fearfully among the crowd: Captain Blackeye.

Try as I might, however, even the most pirates became sullen and secretive when I steered the conversation towards the location of these thrilling adventures; whether they thought me a fool, an interloper or perhaps a Trading Company spy, not one among the group would talk to me about the Sea of Thieves.

Having drunk more than my fill last night, I was teetering on a cliff-edge of hopelessness when my weary eyes caught something glinting far across the room — a single coin glinting in the firelight, its mere presence instilling awe in the pirates. The sight of it inspired something different in myself, and the sudden burst of recollection was like a sobering slap to my cheek.

I had seen such a coin before, in the study of my father.

Cant believe he had an Ancient Coin under his nose! Lucky ~~little~~ Language!

LAST RESORT: A GIFT? OR A BRIBE?

The coin is in my palm, heavy with the weight of history. It is certainly older than my father, older than this estate from which I shall presently set forth. It may be older than the trees that litter the grounds, and I am certain that it can have only one long-distant home.

From what little I have been able to deduce, these coins were a currency on the Sea of Thieves, though such a word perhaps devalues them. A pirate would be considered vastly fortunate to have a couple about his person, for these coins were most often used to accompany promises, oaths or allegiances. To break a bond forged with one of these ornate trinkets would be unthinkable.

If someone is willing to take the coin from me then they shall owe me a great debt indeed. Should they be willing to repay me with trust, loyalty and experience, then I will finally be on my way to the Sea of Thieves.

The suspense! Will he make it??

We have his journal now so I would say yes

Yes, thanks for that. Still, without that coin — he'd just rot away in his house. He got lucky.

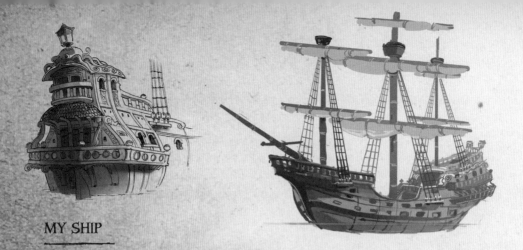

MY SHIP

My new companion, Isidro, has taken my coin but is by no means my servant. He sternly dismissed any notion that we would set sail in a mighty galleon, shored up with livestock and soldiers to ward off would-be rivals. With little fuss, he set about the port in the company of my coin purse and by sunset had secured us both a vessel and a crew to help bring her to life. They were not the crew that I had expected, and that was just the first of my preconceptions to be scoured away during our voyage.

The Sea of Thieves, it seems, is truly a wild frontier. Resources can be scarce, and half a dozen people are just as likely to prosper as a small army when cut off from support and the luxuries of a bustling port town. With such a meagre complement, I had half expected the chain of command to be absent entirely, and was thusly astonished when Isidro declared to the assembled deckhands that I was to be Captain.

Captain Flameheart!

Of course, these men and women are strangers to me, and are accepting of my leadership and my gold only because of their loyalty to Isidro, or so it seems. We shall be sailing in close quarters even so, and I hope to learn about them even as they take the measure of their new captain. Given time, I would like to be able to earn the respect worthy of my title.

Isidro! Its people like him thats why we have Trading Companies sticking their noses into our lives.

It's a big ocean, Bel. We've never even spotted a Company ship.

Good!

THOUGH NOT ANY OLD GALLEON...

Galleon, I should mention, is quite the general term for these largest of sailing ships. The vessel in which we shall voyage is far smaller, although I suspect spacious enough for our purposes.

The Captain's Cabin, located astern, will afford me some measure of privacy for washing and other activities, and its singular location above deck boasts a panoramic view of the seas we shall be sailing. A small chest has been provided in which to store my personal effects, this journal among them, and in quieter moments I hope to keep a record of our journey.

Much of the upper deck is largely functional; the ship's wheel, capstan and other minutiae of sailing that I had expected to find. Below deck I found much more to discover, including a small galley and plenty of snug corners for the crew to rest and relax, but the whole affair was dominated by a tremendous table flanked by benches. When not being used for meals, an enormous map can be found unfurled here, and my heart danced at the sight of unfamiliar names and shapes scattered across the parchment underneath my fingertips.

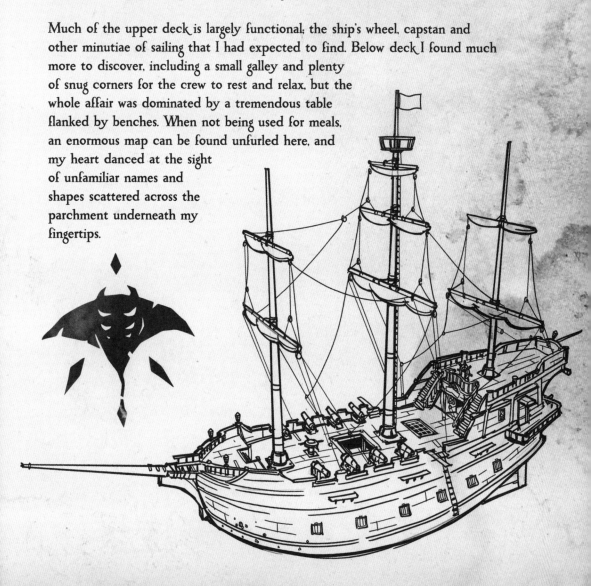

The lowest of the decks, it seemed, was mostly reserved for storage and supplies, though I found what could only be described as a small and squalid brig tucked away behind a pile of barrels. When I asked Isidro what sort of suspicious mind had felt it necessary to include such an unhappy place, he simply shrugged and went about the ship's business.

I shall see to it that there is never a reason for the door to be locked.

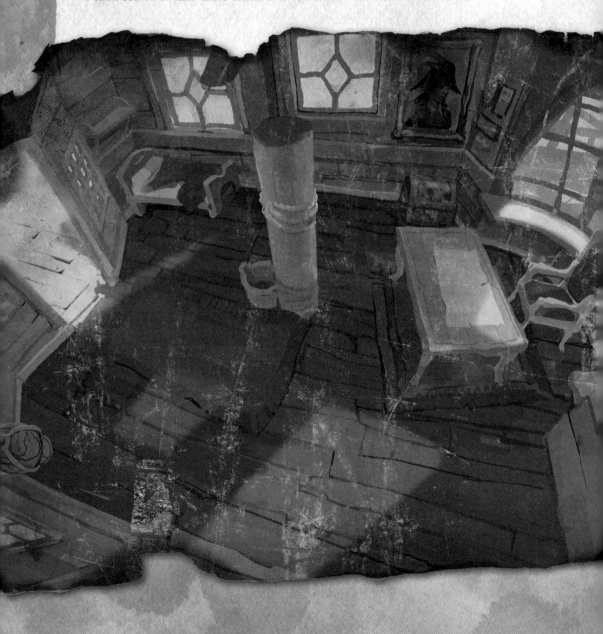

AND NOT MERELY A FIGUREHEAD

I should like to choose my own figurehead, though
I have been cautioned to ask first if the existing
one wasn't carved in honour of a wife or daughter,
imagined as a goddess. Sawing such a thing off the
bow and then setting fire to it would sully any
goodwill gained with my coin.

In any case, a new figurehead shall be commissioned
for this ship, to signify the principled intent of my
voyage. It certainly won't be a female merely to
serve some old superstition. Now, a lion would set
the tone well, though it would require a talented
carpenter to imbue the desired noble look, lest
it resemble some bedraggled feline as I have seen
around.

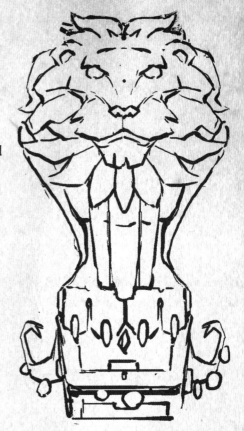

A popular deity would convey great power, and
command over the seas, neither of which I possess,
though the crew might with good humour agree to
sail under these pretences.

Among the sketches that I had couriered to
my door, while admittedly disputing my earlier
comment, one spellbinding portrayal of a girl setting
free a dove speaks to my heart. She is gripped by
what I presume to be the cold hands of death,
therefore this delicate bird may signify the human
soul. Giving flight to the soul... yes, this is what I
would like for my crew.

My ship!

*I wouldve gone with the goddess myself because you needed all
the help you could get. And because I like the idea of goddesses
and dont think about death much because no need*

*This explains an awful lot, thank you. I am just
kidding. Or am I?*

That's my line. So?
So. Haha seriously stop this now. Or? Stop!

HOME SALTY HOME

~~Dear reader.~~ Ship's Log

This is my fifth morning at sea. I haven't felt
well enough to contribute anything in writing
until now. Having just survived a quick tour
of the deck without losing my breakfast, I am
willing to believe that I have found my sea
legs. The ship is intact, which is the main
thing, and headed on the first leg of our
voyage to the Sea of Thieves.

I had wished to name her
Liberdade, meaning 'freedom' in two
of my favourite spoken languages,
but Isidro assured me that to strip
a vessel of her given name can
bring terrible misfortune. Wishing
to maintain a shipboard harmony, I
consented and we sail under the name she came with: The
Silver Blade. While hardly representative of my desire to
find myself anew out on the ocean, I suppose its name sounds rather fearsome,
and may at least give would-be attackers pause for thought.

*Silver Blade is a better name because people know
what it means. A name with no meaning is just a
noise. Really Nura all these silly dreams of his.*

*People need dreams Bel. You have been lucky
to have most of yours come true.*

Which includes you?
Yes, well done.

I believe it is customary for the captain to make a record of operational details
in case of accident, and the need to put everything back as it was. I couldn't
find such a document from the previous captain, so I will provide an honest
report of first experiences instead. While I believe I have successfully left
the shackles of a scholar's life behind me, perhaps one day I will publish my
adventures if there is interest.

This would be fantastic. However...

This journal is ours now, ha!
Exactly.

THIS IS THE LIFE

While the *Silver Blade* appears colossal from the outside, I could swear that it
grows tinier by the hour once inside. I find it amusing that there is more space
afforded the tiller than the Captain's Cabin, although the latter is the most
luxurious location on board. I now entertain two theories why many shipmates

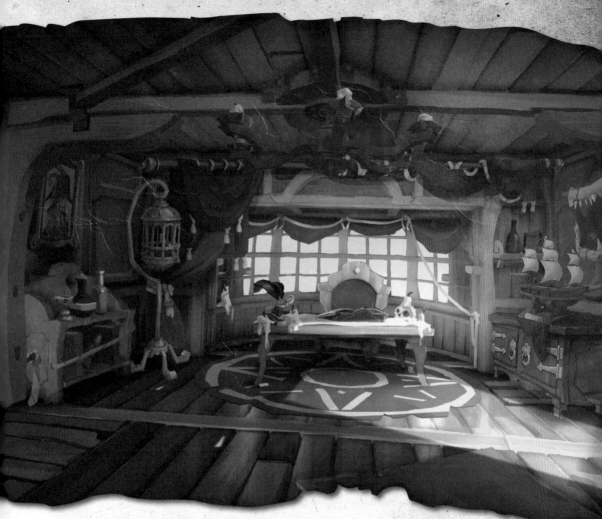

are considerably shorter than the person in command: to make the captain feel important, and to suffer the squeeze on lower decks.

Never noticed this. You're just lanky, Faintheart.

Perhaps when this ship first set sail, an average person's head height was ideal. However, I must walk with a small stoop wherever I go below, making me look ponderous, or suffering from indigestion, which is in fact the case on both counts, but I miss being upright indoors.

While I bang and bump my way around the ship, my crew tend to shipboard life: taking turn in the crow's nest, shouting warnings of reefs and rocks to whomsoever is at the helm, angling the sails to more readily catch the wind and mopping the deck. Above all, they banter with one another constantly, trading jibes, jokes and insults with the rapid-fire wit of good friends.

CURIOUS OBJECTS

As I am determined to comprehend every inch of the *Silver Blade*, I have taken the time to examine and note the purpose of even the most humdrum items. Some features of the ship, like our two rows of cannons, require little in the way of explanation. Yet for all their simplicity, the purpose of the battered metal bucket, stacked purposefully alongside innumerable planks of wood, eludes me. This will not do. I shall have to ask Isidro.

They are tools! Unconventional, to be sure, but connected. The planks are to be nailed across holes in the ship's hull should we spring a leak, and the

bucket must be ferried up and down as many times as necessary to remove any water that might otherwise threaten to sink us. Strange to think that a humble pail might mean the difference between a happy landing at port or utter calamity.

THE CROSSING

For all the growing fondness I feel towards my crew, despite the mutual candour Isidro and I share, it seems that I am not yet a pirate in their eyes — not one that can be fully trusted, at any rate. Last night, while I slept, our ship crossed into the Sea of Thieves, but how? I look up and see, much to my disconcertion, a strange and shifting constellation of unknown stars.

They would not be drawn on the matter, declaring it to be as much a matter of instinct as information. It was darkly implied that we had passed through some deadly threshold or other that might easily have left us marooned, or worse. The Sea of Thieves appears to be lost in the crease of a map; one must know that it is there to find it.

Still, my disappointment at the subterfuge is heartily outweighed by the excitement of finally reaching these legendary waters. Isidro tells me that here, the bustling ports I am used to, are more like frontier towns. Rough and ready, and lacking the luxuries of home. I have asked him to set a course for an outpost.

I feel that I must plant both feet on dry land to learn see what fate has in store for me next.

Lucky! I hear most ships don't make the crossing in one piece.

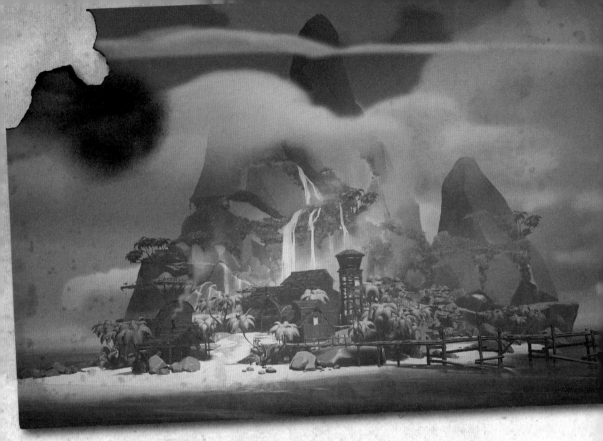

AN OUTPOST FOR ADVENTURE

Though I must take pains to point out that no settlement in the Sea of Thieves is much larger than a fort or a fledgling outpost. This is a gathering of convenience and not some rural commune as you would see back home. Everyone is here to buy, to sell, to drink or to seek the service of another.

So it was that I unwittingly had my first encounter with a Trading Company, or at least one of their envoys. He was dressed rather smartly compared to those around him, with a number of bejewelled rings and other knick-knacks about his person, though I was most intrigued by the streaks of pure amber that ran the length of his right forearm as though his very lifeblood was shimmering, molten gold flowing just beneath the skin.

He introduced himself as an ambassador of the Gold Hoarders, and his sharp tongue swiftly wrapped me in a tale of an antique chest, its lid closed tight by an ancient lock so devious that it could never be forced nor picked. Only one with a suitable skeleton key, which he assured me he and his fellows possessed, could extract the contents. I would be rewarded handsomely for my efforts with a considerable sum of gold and the company's sincere gratitude.

When I enquired, politely, why the gentleman did not simply follow his own map and "cut out the middle man", as it were, he laughed airily. "Ah, let's not be so clouded as to think these waters can't be treacherous," he confided with a wink. "This is a job much better suited to people like yourselves."

Laziness, then! Or perhaps timidity. Either way, he could either see no distinction between my hardy, boisterous crewmates and myself, or he chose not to mention it. Unexpectedly moved, I gratefully accepted the outstretched map.

SOMEWHAT SHOCKING

My crew has besieged an entire beach-side tavern. We'll have drunk this place dry by dawn, with the campfires still burning. Some of us sit clutching our knees, peering out into the darkness off shore, listening intently for the crunch of a ship hitting the rocks, lured by lights on the reef.

I will not bring myself to cheer so loudly as all the rest... though I cannot suppress a smile.

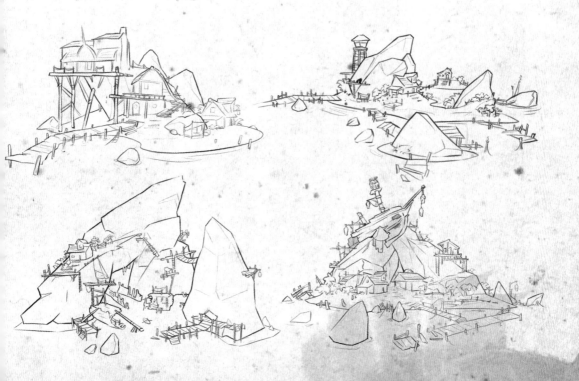

AT THE MARKET

This morning I am calmed, moments ago returned from a stroll among pirates in the most wonderful market place. So much of the hardware on display in the street appeared to have lived a lengthy and interesting life of its own, with at least one previous owner ("At least you know it works, sir").

Everything I have read about Trading Companies back home implies that, by rights, they should be the mortal enemies of those who pick a pirate's life. Here it seems as though the old differences have been largely forgiven, if not forgotten, and Company Traders lounge alongside independent business owners dealing in essentials — weapons and tools, materials for repairing any ship, and so on.

I'm sure that I tripped over the same elderly lady at least five times while gawping at the surroundings. She was gracious about it on every occasion. Just as I thought that this was becoming a little peculiar and possibly annoying she was no longer to be seen. I can recall that she had an unusual smell about her, like incense. What a life she must have led here.

I would wager that this was the most spendthrift supplies excursion that my crew had seen in all their born days. My crewman Red Rosie appointed herself quartermaster for the day, apportioned generous coin to those that knew how to spend wisely, and even tossed a few small coins to the barmaids to enjoy as they would.

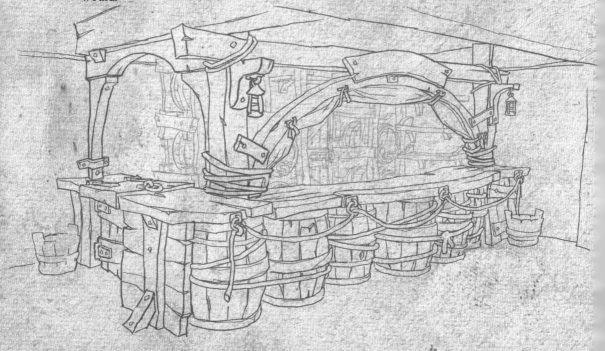

Watching the haul being returned to the ship – ripe bananas and fresh meat alongside the barrel hoops and bags of nails – I grew more attached to the *Silver Blade*, beginning to take care of her.

THE PIRATE PEOPLE

While there is extravagance among pirates, there is naught that I could tell you is wasteful. If wigs, powder or paints are used it is to express individuality rather than to conform or disguise scars and imperfections. Each pirate is the image of all that they have endured and thus far become, from an eclectic mixture of brusquely assembled garments – shared equally among the sexes with no notion of one's gender confining one's choice of outfit – to symbols and messages etched into their skin. Facial hair is commonplace on men and women alike, and serves both to intimidate and impress.

Above all, you may only know a pirate from tales told in their eyes. A pirate's tongue, I have learned in every situation, enjoys playfully escorting listeners to a place that suits them best. Sometimes to emphasize an important truth or build the punchline to a joke, otherwise to protect their secrets. If you have nothing cunning to say, your mouth was made for beer.

I thoroughly enjoy this 'verbal fencing', and have become reasonably good at it.

Pride comes before a fall Mister Fencer. I hate it when he does this
Me too but the man is a scholar. Was a scholar.
Oh I think he is still a scholar even if he wants to be a pirate that's why I worry
It's what you do. You just don't always call it worrying.

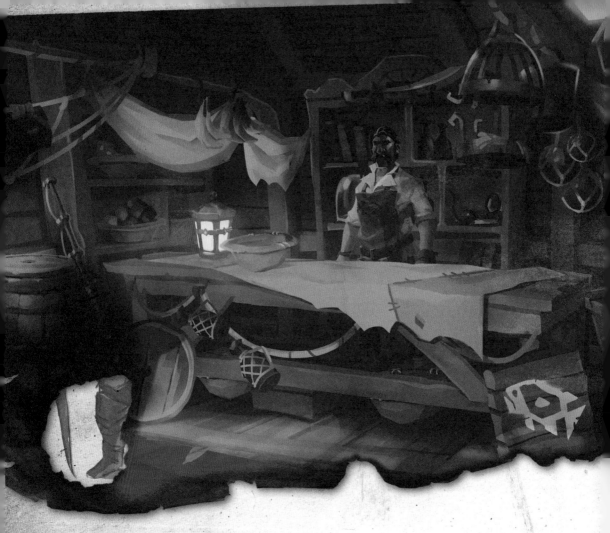

A CHANGE OF PLAN (IF THERE EVER WAS A PLAN)

Late last night Isidro knocked on the door to my cabin. It was certainly very late, as the crew were already resting ahead of departure this morning. He apologized for taking my time, while at the same time leading me off the *Silver Blade* in the company of two sullen, silent strangers I vaguely remembered seeing around the outpost earlier that day.

It wasn't one of the usual pranks, the route we took back into town was direct, with only torchlight to guide us between the buildings and eventually across the empty dock. Silently, although Isidro stumbled over a sleeping cat, the men pointed us to a tiny wooden shack with soft light flickering beneath its door. Inside was the charming old girl that I had seen at the market, thumbing tobacco into a slender clay pipe.

Isidro chose that moment to inform me how a reliable contact had suggested a meeting. Why so late at night? Surely the poor dear needed her rest. It was a requirement, he said.

She wouldn't give her name, only her message, which, as she spoke, I noticed Isidro staring wildly at me as though waiting for a reaction. There is a place, an island, a great distance from here, that holds a secret so valuable that she has been holding onto it since a little girl.

Rolling up her sleeves, we became aware that the old woman's arms were covered in a netting of intricate tattoos. Perhaps it was just some trick of the firelight, but even now I swear that the ink seemed to flow from her fingertips like water onto the blank parchment beneath them, revealing an intricate and unsettlingly real depiction of far-off shores.

Only I could elect whether or not to lead my crew on such a voyage. I was warned again in no uncertain terms that this excursion must take place soon, lest the island once again be swallowed up by the mists of fate. At this, something inside... my heart, my soul? Something curious took shape. It felt like recognition.

And so it happened that I said Yes.

And then she looks at me as though she knows me better than my father, holding my gaze. Isidro takes the map for me as I remain stood transfixed. At some point, the old girl, I can see her as a child now, visibly more relaxed, sits down and waves toward the door. It's as though we are no longer there. And so, I bow and we leave.

The cat from earlier was outside the door waiting, and followed us all the way back to the ship, curling itself around Isidro's legs much to his constant, stifled, annoyance.

When I woke up I thought it was a silly sort of dream. But here, on my table, is that map.

Oh it gets good now Nura. Well it gets boring again first but then it gets good. Really good.

Okay, thank you, I am reading.

CAPTAIN FLAMEHEART

I shall describe the person I see beside me in the mirror, sitting at the captain's table, peacock quill in hand... slouching terribly. Now straight backed. That's much better.

I have a cleaned (I insisted), loose linen shirt that has its left cuff torn off, stuffed into dark knee breeches that may have originally been scarlet, now patchy and brown. The matching tunic, much brighter in hue, is hanging on the wall as it is too hot and heavy for indoor use.

My coarse woolen stockings are pulled up over the knees, my feet are slid into comfortable (second hand) black buckled shoes. There is nothing too fancy about any of it, in fact being practically dressed is the main thing on the ship. I do look fine, though. I say with modesty.

I also have a huge, broadcloth coat that smells like its previous owner(s), which I shall only put on when the weather turns foul, if only to rinse it cleaner each time. I have halted from enquiring about the worrisome rips and stains whenever the question has entered my head.

Who even does this?

I found it interesting.

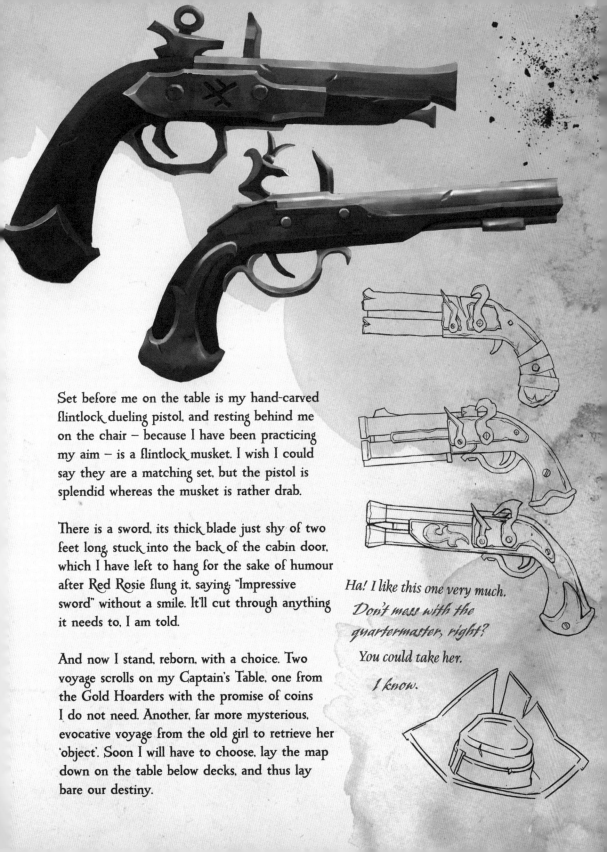

Set before me on the table is my hand-carved flintlock dueling pistol, and resting behind me on the chair – because I have been practicing my aim – is a flintlock musket. I wish I could say they are a matching set, but the pistol is splendid whereas the musket is rather drab.

There is a sword, its thick blade just shy of two feet long, stuck into the back of the cabin door, which I have left to hang for the sake of humour after Red Rosie flung it, saying: "Impressive sword" without a smile. It'll cut through anything it needs to, I am told.

And now I stand, reborn, with a choice. Two voyage scrolls on my Captain's Table, one from the Gold Hoarders with the promise of coins I do not need. Another, far more mysterious, evocative voyage from the old girl to retrieve her 'object'. Soon I will have to choose, lay the map down on the table below decks, and thus lay bare our destiny.

Ha! I like this one very much.
Don't mess with the
quartermaster, right?

You could take her.

I know.

SOME FINISHING TOUCHES

With the basics taken care of I can now afford time to dream up some reputation-boosting details that, the more you look, the more you find fellow pirates attempting the very same.

I was in my 20s when I last tried to grow a beard and it practically blew away like cotton wool in the wind. But this week I have, purely through laziness, allowed an impressive growth to cover my chin and get stuck under my nose. It smells a bit like a brewery.

The tattoos I have seen some of my crew wearing are personal to them, but until this moment I have no such treasured memories worth inking permanently onto my limbs or across my slender torso. There will come a suitable time, though, of that I am now sure.

A song is seldom far from the lips of my seafaring fellow rapscallions, it is true, but there are occasions where the purity of sound from a fiddle says enough all by itself. As a former linguist, to become a skillful practitioner in the phrases wrought from string and bow is my new dream.

Red Rosie has a Hurdy Gurdy that gets passed around while the crew waits to be fed. Some of them have become quite good at stumbling through simple well-known melodies, while others fall about laughing after a few seconds spinning the handle. It's not for me.

I decided to bring father's spyglass with me, which has been a peculiar experience, peering through the same lens as he, plotting my own journey across the sea. I sometimes feel as though he is standing over me, like he did when I was very little, when he had time.

Found this wooden box full of rings of all sizes, at the back of the old crew wardrobe. Rings for fingers, rings for noses, rings for toes... a small detail that I hadn't given much thought until now. I'll slide on the ones that fit, and see if anyone comments over dinner.

PENNY ROSE

TROUBLE THE CAT

Nobody is now more certain that the old woman's tale of hidden treasure is true than Isidro, and so the decision has been made and we are following the old woman's map, cutting across the very heart of the Sea of Thieves. And this is all because of that blessed cat, now the ship's cat, though in truth the svelte little thing belongs to the one she first befriended. As for Red Rosie, she detests the creature, but is prevented from tossing her overboard owing to seafaring superstition.

Cats are often particularly sought after by superstitious sailors, though it is luckier if the cat chooses your ship than if you choose one. Should you bring a cat on board against its will, by trapping it, it is a great misdeed. If a pregnant cat upon your ship gives birth your ship will be blessed with one year of very profitable good luck for each kitten born. The other usual benefits of having a cat around also apply.

The entire crew now keeps a close eye on the animal that has earned the name Trouble, owing to her tendency to trample over the map table and sharpen her claws on bare legs.

Trouble always makes a bee-line for her new owner on deck, this is regarded as extremely lucky. Special precautions are taken to ensure that Trouble never falls overboard.

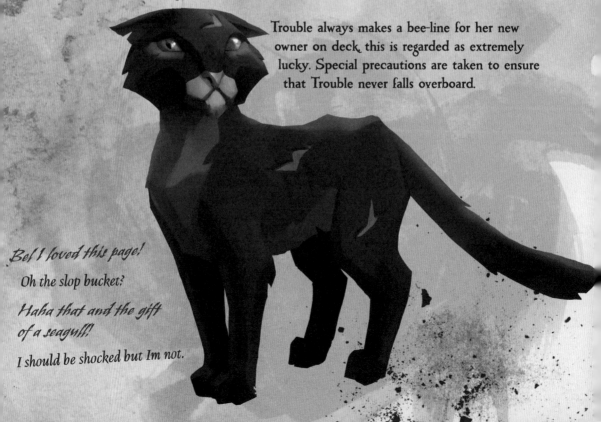

Bel I loved this page!

Oh the slop bucket?

Haha that and the gift of a seagull!

I should be shocked but Im not.

Tomas, youngest of our crew, once fashioned a hammock for Trouble, but she prefers to settle on Isidro's head, digging her claws into it while purring.

Isidro has pointed out that Trouble can predict the weather, would you believe? If she's fidgety and constantly yowling, we're likely to see a storm. If we would prefer to avoid storms completely, he says, we are to keep Trouble happy to subdue the "storm magic" in her tail.

Myriad mishaps are blamed on Trouble (see below), however I am sceptical about these superstitions, and in any case the ship's cat is supremely brilliant at catching mice and sometimes rats. These tiny villains scamper constantly, and are far too swift and cunning to get caught by clumsy human fingers. Trouble ensures that they do not live long enough to dine on the ship – that is, literally chew the timber and rope holding our vessel together.

All kinds of Trouble (I shall keep adding to this list):

Whenever I sit down to write, Trouble hops onto the page to perform a pas de bourrée

Whenever I sit down to read, Trouble thinks it an ideal opportunity to rub her face in it

Trouble has made some of the crew nauseous by drinking from the slop bucket

Trouble pesters the crew to share food from our supplies, then spits it out, then walks off

Trouble faked a limp when she arrived, seemingly for sympathy's sake

Trouble locked Tomas in the brig by headbutting the door closed with him inside

Trouble somehow caught a seagull and left its remains under my pillow.

THE FIRST BATTLE

Like so many tales relayed to me in my journey across the Sea of Thieves, details of the confrontations and skirmishes that filled the first days of this region are lavishly decorated with embellishment and exaggeration, the unsullied facts of the event all-too-often lost in the murk of a rum-filled tankard.

One particularly unpleasant individual waylaid me with his own account – he had seen, or so he claimed, the legendary Pirate Lord setting sail on his maiden voyage. The scallywag became extraordinarily offended when I questioned the veracity of his story given his obvious youth and inexperience - in fact, our heated exchange might have come to blows had his parents not then called him indoors for his supper.

That said, those formative years remain of significant cultural interest to those of us whose purview stretches beyond the barrel of a blunderbuss, and having researched the matter diligently I can state the earliest significant battle to have been recorded impartially was a two-day, three-crew skirmish between more than a dozen young pirates.

Having toiled hard and used all of their ingenuity and guile to reach the Sea of Thieves ahead of their peers, these aspiring louts – many of whom, it is believed, had encountered each other in the past – wasted no time in acquiring three fine vessels – the *Mermaid's Fortune*, the *Mad Monkey* and the *Serpent's Lie*.

One can only imagine the trembling hands that first unfurled the sails of those proud galleons, and I'm told that the inexperience of these young men and women nearly ended their conflict before it had gotten started. The crew of the *Mermaid's Fortune* elected to bolster their resolve with so much grog that even boarding their vessel caused a number of cuts and bruises, while Crewman Dreadswords – who would go on to be a pirate of some renown – was inadvertently and noisily marooned by his own shipmates.

Nonetheless, once all three ships were underway some combination of nervousness, pride or over-excitement compelled the crews to seek each other out and trade cannon fire without even taking time to hoist their respective liveries. Blows were struck as often by luck as by prowess, as the ships came together, exchanged fire and then limped away for hasty repair.

The series of set-tos lasted for two long days, drawing many onlookers and hopeful plunderers to the scene. (Some I spoke to suggested that even the fabled Grogg Mayles was spotted observing the battle, though that stretches the credulity of this humble scholar!) Word began to spread that victory would inevitably be claimed by the *Mermaid's Fortune* and, furthermore, that the *Serpent's Lie* and the *Mad Monkey* now sought to negotiate a parlay.

The sunset of the second day saw the cannons fall silent and the exhausted pirates assembled in the Thieves' Haven tavern, ready to settle their quarrel over a pint of grog. While the defeated crews raised their glasses in a toast to the *Mermaid's Fortune*'s prowess, they consumed nothing and made merry only until their adversaries had drained their drinks.

Leaving the would-be victors tipsy and distracted, the two crews took to their heels and headed for the tiny port where their vessels were docked. They unloaded shot after shot into the defenceless *Mermaid's Fortune* while her crew watched impotently from the shore, swearing revenge on the treacherous braggarts who'd marooned them.

It doesn't take a scholar of human nature to predict what the course of events. No sooner had the wreck of the *Mermaid's Fortune* vanished beneath the waves than the crews of the *Mad Monkey* and *Serpent's Lie* were once again at each other's throats, carried out of sight in a flurry of cannon fire and threats. Details of what happened next, or if either crew survived, are almost impossible to come by. Still, the lesson of this first fateful encounter rings true to this day – be wary of those with whom you choose to share a drink!

While many of the hardened brigands that I encountered in portside taverns or busy marketplaces took a great delight in regaling me with tales of their cunning and bravery, it was surprising how surly or taciturn they would become upon learning of my intention to chronicle their stories in this journal.

Some clearly feared that having their crimes on record in this way might somehow come back to haunt them, while others seemed to distrust the very notion of the written word. "How can paper know what's been happening?", one such fellow asked me sternly.

A few remained resolute in the unlikely sight of my parchment and quill, however, and I have done my best to tell their tales as they were told to me – cleaning up the language and tweaking the odd name for reasons of anonymity. I must confess, it would not do for this journal to delve too deeply into the earthy parlance of the tavern's tongue!

"NO PARLAY THIS NIGHT"

We first stumbled across some easy prey: a docked ship looking for gold. We pulled up right beside them and laid waste to it. I immediately jumped over to see if they had anything of value already on board. There were two chests on board that me and a fellow infiltrator found. My mates warned me that their crew was racing back to their ship, so we grabbed the chests and raced back to ours. The enemy crew was quickly back on their ship and returning fire. I was swimming between both of our ships with the chest in hand while cannonballs flew back and forth.

Much to my dismay, the enemy crew started becoming preoccupied with me. Cannonballs splashed in the water next to me, and this is where I made a grave mistake: rather than swimming around to the ladder on the opposite side, I tried to take a chance and climb up the ladder facing them. I was right at the top of the ladder when a cannonball nailed me in the back of the head. The chest was completely lost! Luckily my ally got his chest safely on board as we laid waste to their ship.

Upon returning from the Sea of the Damned, I saw a very fat enemy pirate walking towards me. "I surrender! Let me join your crew!" he shouted desperately.

I was totally in favour of getting an extra helping hand. I have also not had the pleasure of partnering up with a redname, so I kind of wanted to see where it went. But as soon as I muttered "OK" the portly pirate was blasted full of buckshot.

Standing there with a blunderbuss at his back was the ruthless Pirate James. This crewmate of ours goes against the grain. We don't have an official chain of command for these voyages, so we just have to deal with his savagery. He enjoys stockpiling ludicrous amounts of chests on board and never cashing them in, as well as being as cruel as possible towards enemy pirates. At first I was shocked at what he did, but then I kind of just burst out laughing. I didn't even see him standing behind. All of a sudden the man just died and fell over with Paul standing there in his place.

Before we even had a chance to catch our breath, another enemy ship began approaching us. We contemplated running ashore to cash in our chests, but I realized that our ship, the S.S. Troglodyte, would be sunk if we abandoned her. Their ship was bearing on us fast. We had to fight. Our ships began turning at quite a distance as we both laid out shots, from our starboard to their starboard. We each scored a couple of hits, but we also both ended up drifting further away to where we couldn't reach each other anymore. That's when I noticed something very interesting.

Both of our ships were deadlocked with the helm turned full right. There was no way either of us were going to get any leverage. I recognized this pattern immediately and I intuitively applied my skill at 'cutting the circle'. There was one thing we could do.

I ordered my crew to jump off the cannons and to be ready to raise anchor, because we were about to apply the infamous dead-drop turn in a whole new way. Our ship lurched to the right, and we then picked up speed again as we re-raised the anchor. It worked flawlessly and we had clean shots on them while they ended up facing us directly. We dispatched of the ship and proceeded to the outpost. We ended up completing our second voyage with another mythical chest AND we accumulated over ten thousand gold that day. Thanks to some quick thinking, the S.S. Troglodyte lived to sail another day.

– Crewman Natsu, S.S. Troglodyte

"A DRINK WITH A STRANGER"

Wet… My feet are wet… I look down and sure enough, I'm standing in ankle-deep water. Great, I've woken up during a losing battle. I decide to take action and immediately begin plugging the many holes below deck. Almost every bulkhead now has a patched hole. I now begin the arduous task of bailing water with my bucket.

I call out to see if anyone can hear me. One person replies. I climb the stairs to the main deck to see what's happening. Sails on the horizon. The ship we were fighting has turned tail and run. We have no treasure to lose so we give chase. We're using the same wind, so catching up is an ordeal. Twice, a member of the enemy crew floats past in an attempt to board us. They fail both times. We continue our pursuit.

The enemy ship strikes a shoal and loses a good portion of its lead. It's getting dark and there are lights in the distance. They're making a break for the outpost to cash in their treasure… Not on our watch. We trim canvas to get the most out of our sails but they're going to make landfall. We can at least make sure they don't have a ship to return to.

We cut the wheel hard right and drop anchor. Our ship cuts right giving our cannons line of sight on the enemy vessel. We open fire. Hit after hit, their ship sits lower and lower in the water. We've sunk them. We're victorious. We celebrate by going to the pub to refill on wooden planks and bananas… not to mention grog!

We return to our ship to see yet another set of sails on the horizon. Headed right towards us. Is it the same crew? No time to find out. The rest of the crew heads back to the ship while I sneak to the other side of the island. The enemy ship doesn't seem to see us and attempts to make berth. They pull up their sails and stop at the docks. I report their movements back to my crew. Our ship starts moving in, positioning itself to broadside.

The enemy ship has spotted them. They start spinning the ship around. At this rate, my ship will be a sitting duck. I do the only thing I can think to do. I board the enemy ship, and introduce their helmsman to my blunderbuss. After he's taken care of, I drop their anchor and jump off the boat and make

for my ship and my crew. Once again, we watch the enemy ship sink. Victory music is played as a salute to those sailing on the *Ferry of the Damned*.

What's this? An enemy pirate swimming towards us? We make for the cannons, but he's too close. The cannons won't angle down that low. We all pull out our pistols and blunderbusses and prepare for a gunfight. He stops. He's talking. He yells up at us that he's the only member left on his crew. Apparently they all left after our first run-in. We take pity on the lone scallywag and offer him a ride back to the outpost. He thanks us as we weigh anchor and make for the beach.

We drop him off, and we're about to go our separate ways when he asks if we want to join him for a drink. Being rum-soaked brigands, we cannot refuse. We proceed to the Drowned Rat and drink until we can't walk straight and the inside walls of the pub look like one of Jean's rotten fish stews. We then say our goodbyes but not before our lonely friend gets a new crew member. Not long after, there are eight of us standing on the beach playing our various instruments. It quickly devolves into a fight, but instead of trading bullets and gunpowder, we're soaking each other with buckets of water. We then decide that the barmaid probably needs to be doused as well. Eight buckets to the face and we're all dying laughing.

A few laughter-filled minutes later, we get the idea to join forces and hunt anyone else on our side of the sea. We swim out to our respective ships single file, playing music the whole way. We split our crews loaning one member each to stay on the opposing ship as a way to communicate, then we set sail. Unfortunately, we find no enemies. No sails are seen on the horizon. However, our time on the open seas teach us that the most fun is had when you're not looking for a fight. Simply having a drink with a lonely stranger is all you need to have a good time in a sea of thieves.

– Captain Thugzz Deluxxxe

NATURAL HISTORY

Our thrilling new course is plotted to point the *Silver Blade* through unknown
waters, during an uncooperative time of year regarding weather. Therefore,
the whole crew has become nervous while preparations are diligently made.
As part of this new routine, we are making numerous stops at smaller islands
for seafaring specifics. And this, my unknown friend, has presented me with a
unique opportunity!

These islands host a wealth of natural history, with flora and fauna that would
take several lifetimes to record. Inside of several days, I have applied my
rudimentary sketching skills to the business of scribbling down some of the
wonders I have seen, with some explanations.

Told you he was still a scholar...

Some Companies will pay for birds and fish, you know

Also scholars then Pffff

BIRDS

Small thickets and wider areas of bushes and trees are alive with the delightful
twittering and fluttering of birds. Majestic herons could teach our fishermen
about patience. I rested my own eyes on the tiniest of hummingbirds, after only
seeing them in books. Most curious of all was a very large, slow-moving and
flightless bird that gorged on berries and tiny crabs. I believe we shall be dining
on him tonight.

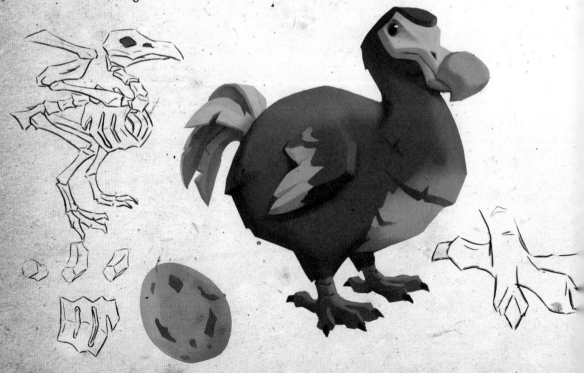

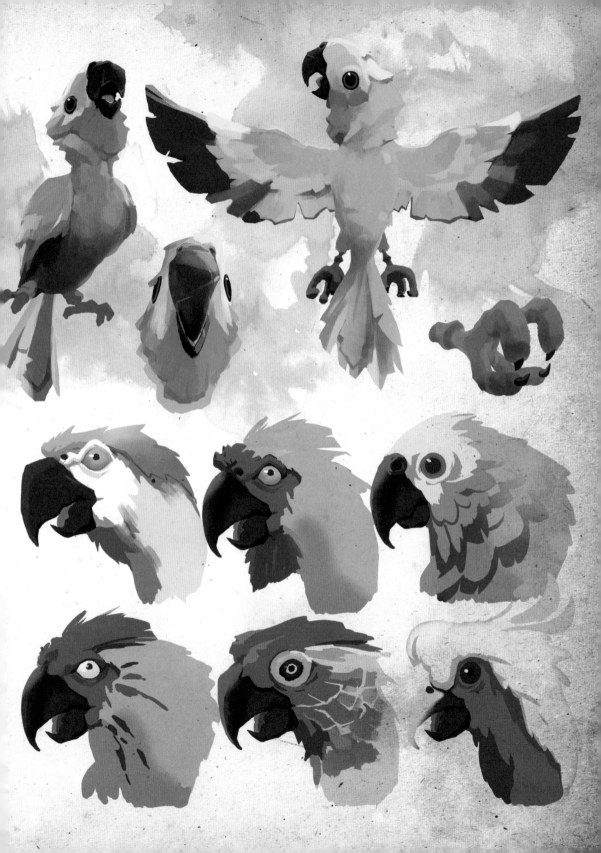

FRUIT

Speaking of food, I could not have dreamed some of the appearances and textures of the fruit that we have picked. The crew took delight in serving me slices of the most peculiar specimens, with brightly colored seeds and polka-dotted skins, and some that I might've mistaken for small animals curled into their protective shells. Forcing into my mouth these most refreshing treats was laughably among the most intimidating challenges.

FLORA

Flowers and plants around these fair isles are as precocious as their pirate counterparts. They take on forms that are one thing and another combined, with delicate petals perched atop resilient stems sprouting the sturdiest of leaves. One almost gets the impression that even the tiniest of weeds aspires one day to become a glorious tree. The only thing stopping them is their piteous role in the food chain.

The fruits and the flowers blah blah blah blah blah blah

What? Its called paying attention to the world around you Nura. Its good for your mind and your soul. Honestly I learn a lot about life and the order of things from watching nature.

So you have the mushrooms to thank for a smooth running ship?

Yeh it is something like that. I can tell you a lot about mushrooms.

Please don't. Ever.

INSECTS

These tend to grow terribly large, and since I am uncomfortable around wasps and bees at the best of times, an angry-looking 3-incher soon saw me retreating. I spied one huge wasp chasing after a very big spider, a tarantula I think it was, to give you some idea. Mosquitos are almost everywhere, as are ants, which I don't mind. There was a scorpion hiding in my sack this morning. I sent Trouble after it.

SNAILS

Crouching to examine the undergrowth, one's eyes gradually adjust to notice so many types of snail sucked onto trees, miraculously balanced on top of bushes (Did they fall or fly?) else waiting on the floor to get eaten. Some of them will provide quite a mouthful for an average beast, growing to 8-inches or more in length – larger than my hand! I prefer the smaller, colorful mollusks with spiraling shells.

CRABS

My attention was held by a curious number of hermit crabs that were found very far inland. Purple-clawed and bearing the distinctive black and white shell of a sea snail, I caught them closer to the roots of trees than the frothing seas. So too were a variety of crab that had one enormous claw and eyes on long stalks, except these appeared from burrows underground.

Whatever next? Sea snakes? Ha!

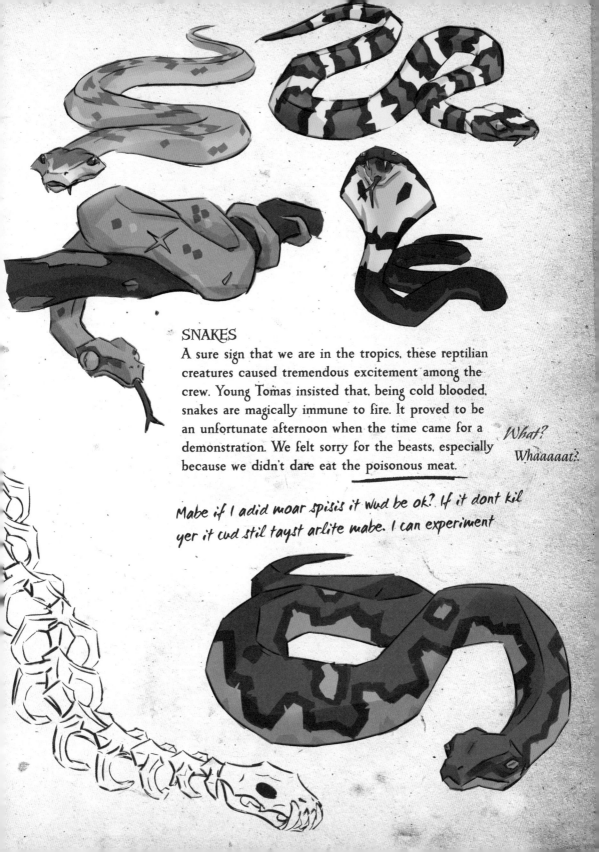

SNAKES

A sure sign that we are in the tropics, these reptilian creatures caused tremendous excitement among the crew. Young Tomas insisted that, being cold blooded, snakes are magically immune to fire. It proved to be an unfortunate afternoon when the time came for a demonstration. We felt sorry for the beasts, especially because we didn't dare eat the poisonous meat.

What?
Whaaaaat?

Mabe if I adid moar spisis it wud be ok? If it dont kil yer it cud stil tayst arlite mabe. I can experiment

WATER PIGS?

We made a special detour to procure fresh meat, having spotted a number of boars taking a dip off shore. Red Rosie claims to have a special recipe for grilled pork smothered in a thick, salty sauce, laced with lime and pepper. Isidro scoffed and informed Tomas he'd be swabbing the decks clean of the aftermath. I do not know what else can be said about pigs merrily swimming around their own private island, and I especially cannot imagine how they got there.

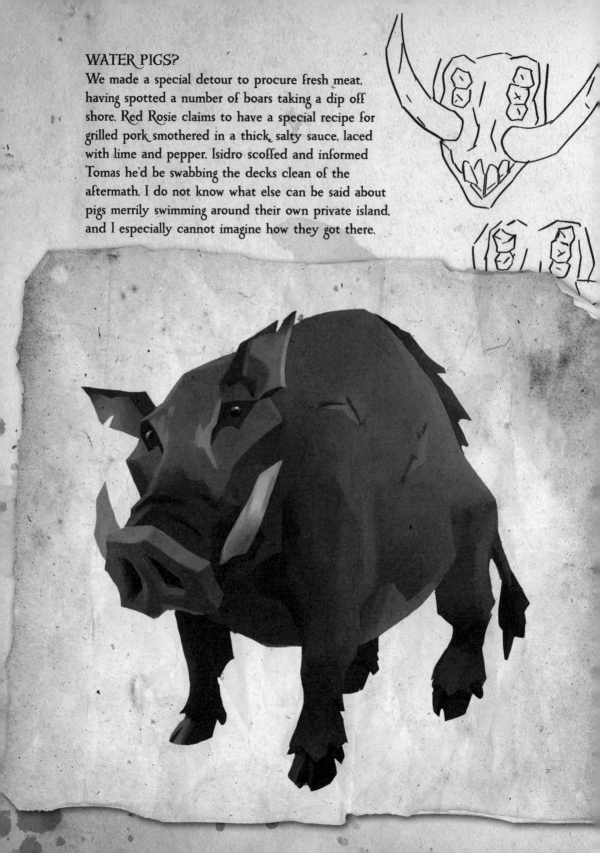

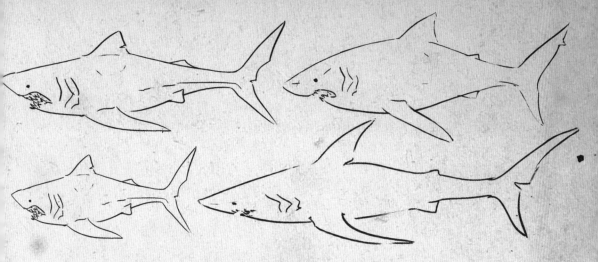

SHARKS

Who doesn't find sharks striking a spark in their childhood imagination the first time you learn of their existence? These cold-blooded rogues with their dead eyes are numerous and sizeable across the Sea of Thieves, and I have been fortunate enough to see one swim past my cabin window, its hulking form criss-crossed with many aging wounds and battle scars.

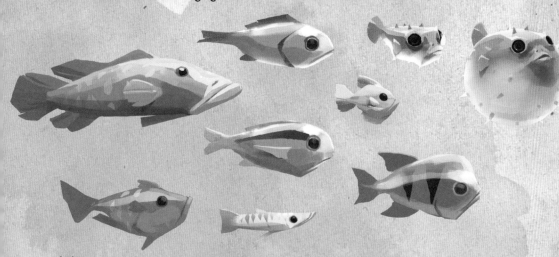

FISH

How I wish there were a way to safely join the colorful fish, dancing below me while we swam. Cobalt blue, bright yellow-striped, spotted, and burnished silver backed. A rowboat may be the answer, and perhaps we can find a way to have one mounted. For all we know about the treasure we seek, it may lie beneath the waves, not conveniently placed on a torch-lit plinth. We may be searching high, and low... and deep.

Wen Bel gets bak we shud visit this iland becus a lot these fishis wud be wundeful to pripare as a selibrashun!

A little over a week from the outpost and we find ourselves becalmed. There is no wind to bring life to the sails, and so the ship bobs listlessly. Without the wind there is an unnatural silence to the sea. Beyond the lapping of the water and cries of distant birds there are few noises. No creaking of the ship straining against the breeze or the sound of the crew hard at work with ropes. It is all quite unsettling.

Thankfully, it turns out the crew are quite talented at creating a shanty and have come up with just such a one for this occasion. I have transcribed the lyrics here. The crew are very pleased it is being recorded for posterity and hope for it to become a common tune all across the Sea of Thieves.

Our ship, she dreams of wind in her sails, of wind in her sails unfurled
And shining as we cross the sea, we cross the sea for home.
Then we'll all raise our voices, a song in our hearts
And set our eyes on distant shores with wind in her sails again.

There'll be cheering and calling
No more squabbling and brawling
When we have the wind in our sails.

When we have our feet on the ground
We'll sow our good fortune around

There'll be feasting and pleasure
No more rationing and measure
When we have the wind in our sails.

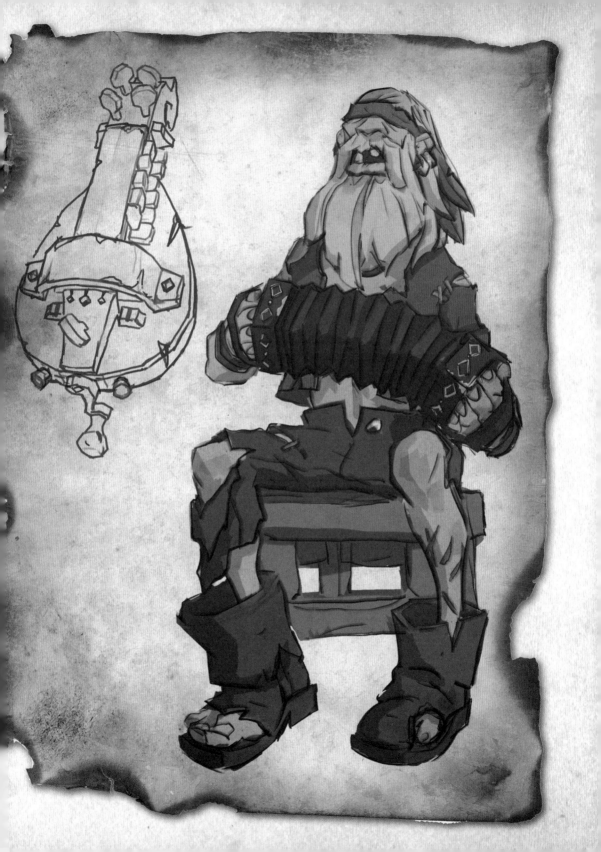

There is much to occupy both body and mind aboard a vessel like my *Silver Blade*, and I find myself coming to regard every infrequent moment of solace as a precious thing. For more experienced seafarers, these lulls in activity soon become tedious, and I have learned that a humble die – or to be correct, a pair of dice – can provide much merriment if accompanied by a snifter of something sinful. I have attempted to discern the rules of these drinking games, and note them here.

CHO-HAN

Were one a firm adherent to the glittering path of sobriety, this bawdy game would seem to be severely lacking in skill and depth. The rules are as simple as can be: one crewman, acting as a dice "dealer" of sort, rolls any number of dice. All other participants simply bet on whether the total will be odd or even, drinking if they should lose.

The rules sounded profoundly uninteresting to me until I took my first sip of greasy grog, rations of which must be consumed to stave off all manner of ailments, at which point I began to see the appeal of a distraction, no matter how mundane, to accompany the drink. Fortunately, alternative games are rather more meritorious when examined in a critical light.

Oh, for the sweet vintage of my family's cellars!

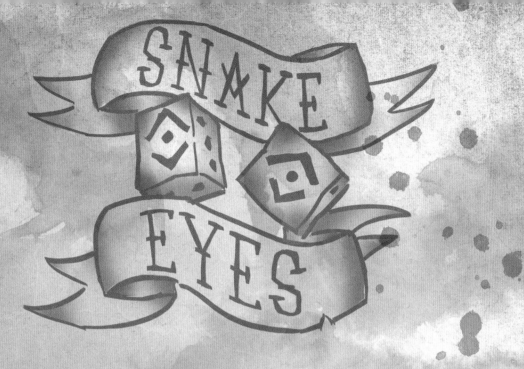

KARNATH

A game for two players, requiring one pair of dice. To begin, each player rolls the dice. The player with the highest roll takes the first turn – if the score is tied, each player rolls again until the order of play is decided.

Once the game is underway, each player's goal is to be the first to reach an agreed total, usually 100 points for a quick round or 500 for a longer game. The player whose turn it is rolls their dice, and the result of their roll adds to their points (e.g. a three and a six total nine points).

The player may choose to roll as often as they'd like within their turn and keep scoring points. Alternatively, after each roll, they may choose to end that turn, in which case the points from that turn are safely added to their total.

If at any point, however, the player rolls a total of seven, they will lose all the points accrued during that turn, and their turn will end, passing to the other player. The first player to reach the agreed total wins the game.

If a player rolls three doubles (two fours, say) in a row, their points are doubled and their turn is over.

LIAR'S DICE

A variant on a classic drinking game that can be played with just one pair of dice. As with Karnath, players roll to see who goes first.

The player rolls the dice, keeping them concealed, to get a score. The score is determined by using the higher dice as the "tens" value and the lower as the "units"; rolling a one and a four, then, would earn the player a score of 4-1, and so on.

The player can then choose to either declare their score honestly or not. If the other player does not believe them, they can challenge the roll — if the challenge is successful, the losing player must drink. If the declaration was accurate, the challenger must drink.

If the other player chooses not to challenge, they must accept the cup sight unseen, and roll again. Whatever their true score, they must now declare an even higher result than the roll that came before, and so on.

One additional rule, the lowest possible roll (2-1) is considered the highest, like a high ace in cards, even above a "6-6". If the player is lucky enough to role a 2-1, since it cannot be beaten, the other player must drink regardless — or twice, should they challenge the veracity of the roll and lose.

BETTY

A uniquely piratical game which I must confess cost my coin purse most dearly. The rules I gleaned from a pair of devilish braggarts who chose, with much guffawing, to declare themselves as being Hark and Pentze, inveterate and successful (or so they assured me) gamblers of renown.

To begin, each player must add their ante into the pot. Miserliness is strongly discouraged. Two dice are then rolled for an arbitrarily nominated player- the pirate with the most teeth, the fanciest hat, or whatever whimsy alcohol bestows upon the group. That player then bets from nothing to the amount that is in the pot currently (a risky gambit when the stakes are high) as to whether the next dice roll will be higher or lower.

Should the second roll match their prediction, they may remove the amount they wagered from the pot. Should the roll go badly, they must add their wager into the pot instead. Worse still, should the second roll precisely match the first, they must add double their wager to the pot — not to mention finish their drink!

Turn then passes to the next player, and play continues until all but one player is either impoverished or unconscious.

CURSED OBJECTS: HOW TO TELL?

Through Isidro's steady hand and Red Rosie's careful management of our supplies, the outward leg of our voyage has been completed, though our destination could not have been less inviting. We were, according to the ship's map, at very heart of a desolate region known ominously as the Wilds.

The sea itself seemed stagnant somehow, and those islands we passed were a far cry from the soft sands and gentle coastlines to which I had become accustomed. These rocks were jagged and cruel, jutting from the water like the crooked teeth of unseen giants. Where vegetation existed, it was straggly and sparse, the colour of bruises. A storm was roiling in the distance, though Isidro insisted it would take some time to reach us.

As depressing as our surroundings were, it only made me all the more eager to recover the object of our quest and return triumphant. Scanning the brackish water for sharks and leaving Tomas on watch, we jumped as one into the shallow water and swam the rest of the way.

With lanterns lit and compass in hand, we struggled across an unforgiving landscape, moving quietly but steadily further inland. It was Isidro who first noticed the calcified tree, its leafless branches and gnarled trunk coated in a thick and cloying dust. Chalk-white dust, the colour of bones.

It was here that we started to dig.

Once hauled free of the sod and grime that had so long ensnared our prize, we found ourselves staring down at a small, slate-black chest that sat surprisingly untouched by the passage of time. Silvery, illegible script crawled across every surface, betraying no clue as to the contents or its original owner. Red Rosie reached out to prise open the clasps, but Isidro stopped her in her tracks with a low grumble – one matched a moment later by thunder on the horizon. It was time to leave.

As I angled my lamp, seeking to help my crew find their way down the treacherous rocks, Isidro broke his silence and began to speak at greater length and with more conviction than I had ever heard him speak before, about curses. These were not mere superstitions as I had encountered before, he insisted, but demonstrably real.

Though none among my crew had met a living soul who fully understood the origins of cursed objects, it transpired that their effects were well-known amongst the pirates whose ranks I wished to join. Red Rosie described a chest salvaged from the sea on her maiden voyage that bore a tormented face where the lock would normally be – a face that shed very real tears at an alarming rate, filling the hold with water and threatening to sink her ship mid-voyage. Only by bailing constantly, ceaselessly, with aching arms and burning backs, did her crew make it back to land alive.

Even more alarming was word of a treasure chest that afflicted would-be plunderers with what had been termed 'The Curse of a Thousand Grogs' – a sudden sensation akin to extreme drunkenness that reduced its victims to jelly-legged sots without so much as a drop having passed their lips. Feeling that all this must surely be leading up to something, I challenged Isidro to state his case if he so had one. "I have said my piece," he declared.

The box is now in the brig, and the door is locked.

Hey everyone were just bringing this cursed chest on board Im sure everything will be fine

 Presumably this is where you meant that it 'gets good'.

Well when I said good I meant bad Nura but in a good way because it really is bad haha

 I think I'll just read what happens.

One of my clearest, most exciting memories was sailing toward a treasure island, and just within range of our cannonballs, seeing an enemy ship sailing back to the outpost. It was a cloudy, windy night, so the sails were full and the waves were high, white with spray, and the moonlight was breaking through the clouds, reflecting off the water. The enemy ship looked absolutely amazing, ominous, spooky, and silent.

We had a hull half full of water, and a Captain's Quarters half full of treasure chests (and yet still going for more - greedy pirates!) I shouted out to our crew, "Turn off your lanterns! We have too much water in the hull. If we fight, we'll be sunk!" Holding our breath, we slipped by 'unnoticed'... I still don't know if they even saw us. We were lucky!

– Crewman Esuns

So, we've got ourselves a legendary chest from this island, and we're hauling away and we see this other ship as we're preparing to go. So what I do is I jump into the water and start swimming after this boat. This boat full of scurvy vermin start to size up our ship. As it sails towards our ship at full speed I manage to cling on to the ropes and climb up, with not much health mind you.

Expecting death I find myself in the presence of three crew members facing away from me ready to blow holes in me crew's ship. So, I quickly jump into the middle deck and then climb up the stairs, only to find that me crew's ship is passing very closely by, side by side, exchanging glorious cannon fire. I dispatch all three of the scurvy dogs with a combination of pistol and blunderbuss.

I run up towards the Captain's wheel and he has ignored me. So I blast his brains out from behind as well. Not bad. I have just managed to murder all of the enemy crew. Anyway, I drop their anchor and search for any loot on their ship but alas none can be found...

– Captain Scraps

The sun was setting behind an island about half a kilometre away when our lookout starts slamming on the bell and letting out somewhat incomprehensible warnings... East... West!... LEFT of the island!

We trim our sails and the coxswain points us straight at a boat clearly raising their sails - getting ready to dig up their treasure, we surmised. With the boat set, the instruments came out to pass the minute or so it takes to reach them, with the distance half-closed yet more squeals from the lookout... BEHIND US! In our excitement, we had completely missed the boat that had been closing on us before setting our sails.

We now have a decision, if we plunder the ship in front we will be attacked on two fronts. We made the tough decision to deal with them one by one. The coxswain cranks the ship into the wind, we drop the anchor and spin to open up with a broadside onslaught. Pointing at us like an arrow and not anticipating our actions they were slow to react. Three of us raised the anchor and trimmed sails whilst the other jumped ship in a boarding attempt.

Needless to say we made short work of them, alas, it was all in vain. Moments later some sneaky rat from the island ship executed us in short order as we drank our grog. Scoundrels!

– First Mate Veetail

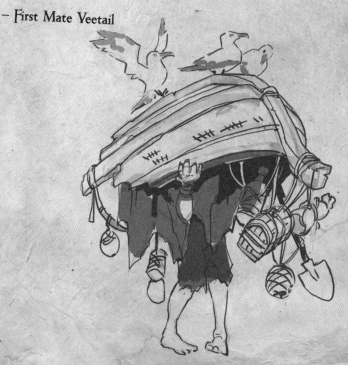

FAREWELL MY *SILVER BLADE*

It is all rather sudden I know, but the implications of Isidro's somewhat theatrical lecture have this morning materialised in the most alarming fashion. What I remember is this...

I awoke before dawn to the sound of the ship's bell, and we staggered onto the deck to find Tomas, shaken and considerably paler than any linen aboard. He had seen a hulking shape upon the dark horizon, he insisted, and no amount of fruitless searching on our part would calm him.

Had Red Rosie not reluctantly agreed to one final sweep of her own from the crow's nest, we would almost certainly have died shortly thereafter. As it was, her cry of "ship ahoy!" gave us vital seconds to save all our lives.

The other vessel had used the tolling of our bell against us, cloaking themselves in darkness and following the frantic sound to launch a sneak attack. Barely had my crew reached battle stations when a volley from our opponent struck us squarely in the side, making the deck lurch so sharply I feared I might be tossed overboard.

I stood stupefied as Tomas pushed roughly past me, watching helplessly as Isidro and Red Rosie clung to their cannons and fired luckless shots into the murky night. I had no expertise with the cumbersome weapons; all I would accomplish was wasting our own ammunition. It was then that my eyes alighted upon the ship's wheel, unmanned and spinning slowly as the tide took us this way and that. The moment I doomed our voyage to failure.

Seizing the wheel, using what little strength the day's exertions had left me with to force a coherent course ahead, I scoured the darkness for some secluded bay or distant cliff that might serve to shield us from the assault. As the sun began to peek above the horizon I spotted a band of swirling mist to starboard, and with a grunt of effort I began to turn our beleaguered *Blade* in its direction. Though we would be blind, so too would our attackers be.

As the first misty tendrils embraced our battered hull I afforded myself a brief glance behind; to my delight, the silhouetted sails behind us were receding and finally began to turn away entirely. A harsh laugh escaped my dry lips as I exulted, intending to suggest – indeed, command – that we drop anchor and lick our proverbial wounds.

It was at that moment the entire vessel began to shudder, and Isidro, his face crimson both from fury and a streaming cut across his forehead, wrenched the wheel from my grasp. "You bloody fool," he spat. "You've sent us straight to the Devil's Shroud!"

Bewildered, I fled below decks to assist in bailing, repairs or anything I felt confident wouldn't bring further catastrophe. As I all-but-tumbled down the slippery steps, I could see the very wood around me beginning to buckle and warp, allowing the creeping mist inside to run intangible fingers across every surface.

Only now did the true nature of this so-called shroud become apparent: the *Silver Blade* was dying, the ghastly fog choking the life out of her with its chill touch. For every hole we patched and bunged, two more ruptures took its place. First we were splashing through ankle-deep waters, then we were wading.

Wordlessly, the others starting shoving food and other essentials into whatever they could lay their hands on, and I moved to do the same, thinking wistfully of the mysterious chest bobbing about in our flooded brig.

By the time I made it above decks, the rest of my crew were already in the water. Isidro's timely actions had finally freed the *Silver Blade* from the brim of the Devil's Shroud, but not before she had been dealt a mortal blow. It was time to abandon ship, and so I tossed my provisions over my shoulder, took one last lingering look at my doomed vessel, and plunged myself into the freezing sea.

Oh dear. What I thought too but in a lot more dramatic words
with some bad ones you really hate me using

I blame the mushrooms.

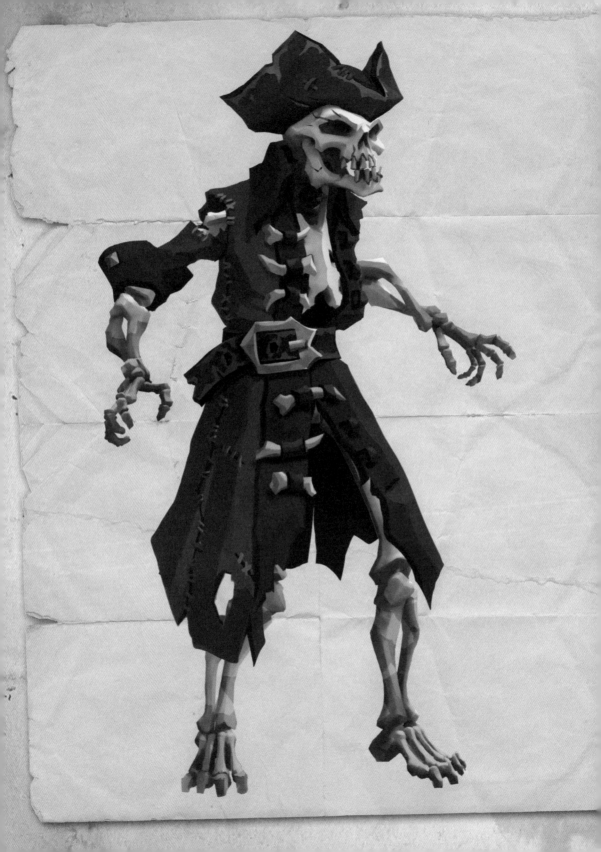

TALES MY PAPA TOLD ME

When I was tiny, my father, or 'Papa' as I called him then, would cradle me between his crossed legs and read to me. Then, as I grew older, I began using this comfortable position as an arm chair, with his chin just over my head. I vividly remember how he'd tickle me with it on my cheek and neck.

I began to learn all these stories, grew to love the illustrations, even the smell of these old books was magical. We read so much through my childhood, now side by side, eventually with me narrating. Just before Father died, we read them all, as though time had stood still.

None of these stories resembled anything like the originals upon which they were based.

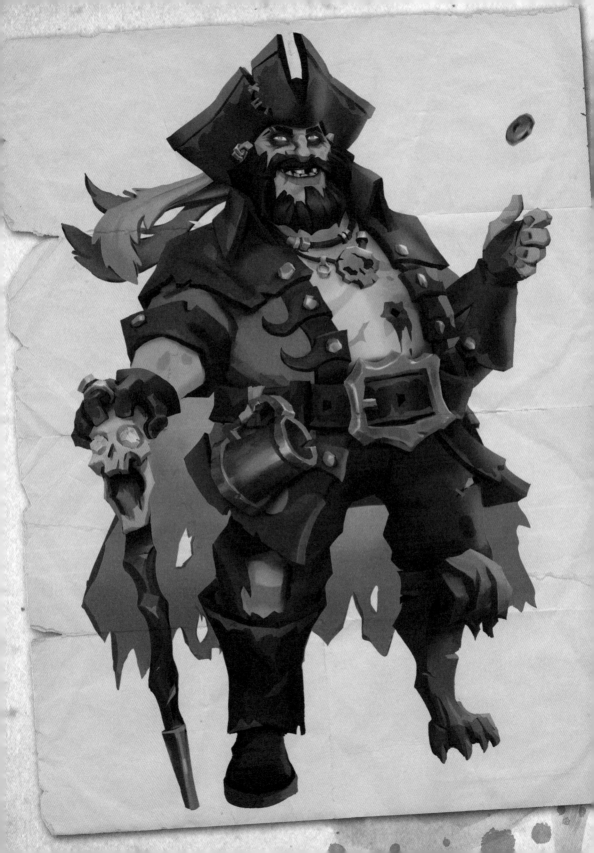

THE PIRATE LORD

Of all the colourful characters my father described to me, none fired up my young imagination more than the avuncular Pirate Lord. His is a figure that dominates many tall tales and flights of fancy, particularly those told to children, and together they paint a romantic picture of pirate life. He visits colourful islands and stumbles upon magnificent treasure, miraculously emerging unscathed from all of his adventures.

Truth be told, it was the Pirate Lord who first put me in mind of running away with the pirates one day. He was one of the first seafaring rogues to discover the Sea of Thieves – that much the tales can agree on – and if not the most successful, then at least the most renowned. In a region where your reputation is everything, that might well be more important than wealth.

His skill with blades of all kinds was exemplary, his cunning unparalleled and his knowledge of the workings of the world could not be matched by anyone who dared to cross him. Even in those formative years, the Sea of Thieves was rife with secrets – any visitor to the Ancient Isles can attest to the existence of an ancient civilisation whose echoes can still be heard in cursed caves and submerged temples.

His voyages are so intertwined with almost every facet of life on the Sea of Thieves – from curses to merfolk to the ancient coins themselves – that it seems impossible that they could all be true. Death itself could not quell his lust for adventure and excitement, and many of the stories I remember most vividly describe him as an emerald phantom, a spirit whose insubstantial nature did nothing to prevent him from enjoying himself.

I am not so vain as to believe that I will ever meet the Pirate Lord. To one day hold in my hand concrete proof of his existence would validate the dreams of my childhood, and that would be enough for me.

FERRY OF THE DAMNED AND ITS CAPTAIN

There is one captain that I fear we all one day must meet, for he is in command of the dread ship known as the *Ferry of the Damned*. He is tall, cold and gaunt, mirthless in the mercy he provides, for he rescues recently deceased pirates from the Sea of the Damned – an eerie miasma which, it is said, is filled with the writhing spirits of the dead.

There is often a price involved. I suspect it depends on how much respect you afford the Captain, but who can say? I would hope never to find out, but several I have met have described the door they passed through, a door where the Captain's Quarters should be, in order to return. My blood ran even colder upon hearing separate stories collaborate on such a detail.

I wonder if it helped Faintheart, knowing all this? I mean, it's fairly accurate at least.

Having not died yet I dont want to say but knowing the way out is important so yes I think it wouldve helped our guy but after that of course not so much hoho!

MERFOLK 'TALES'

The fantasy merfolk of my childhood lived in rainbow-colored coral kingdoms, sang love songs to wayward sailors, and made museums out of sunken human bric-a-brac. Occasionally, our worlds would unite, with the combined magical effect leading to some happy ever after.

Per my stranded pirate friends, they are now on the look-out for gracious mermaids that might return us, apparently in an instant, to the nearest outpost. So far there has been no luck, although one fellow claims to have spotted one or two keeping their safe distance. If ever they were there, they have since departed, most likely spooked by the Devil's Shroud.

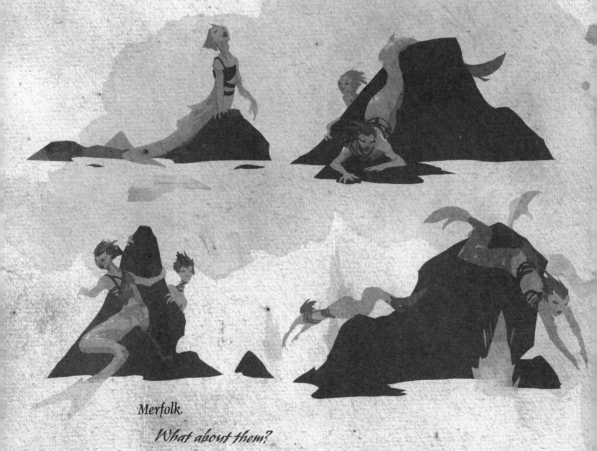

Merfolk.

What about them?

Well this for an example.. . .. always in it for something and never nothing.

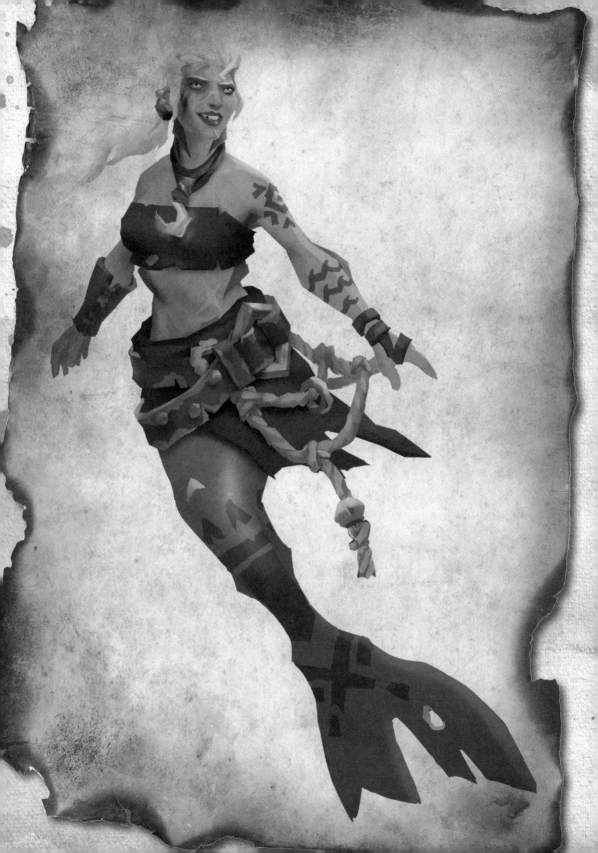

SKELETONS ALIVE

Trust me when I say that among the irregular notions I am forced to accept, this belief in walking and talking human skeletons beats them all. After my brush with the ghastly Devil's Shroud, however, I have since humoured any campfire tale.

It seems that skeletons are a surprisingly diverse group of... I suppose one must still call them individuals, though by all accounts many are as feral as beasts, seemingly driven by some primal instinct still stirred in them after death. Those who retain their minds, despite the lack of a living brain, are often seen commanding their bony brethren, and are considered 'Skeleton Lords'.

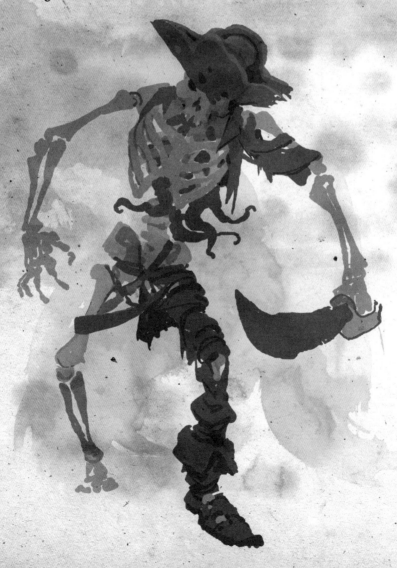

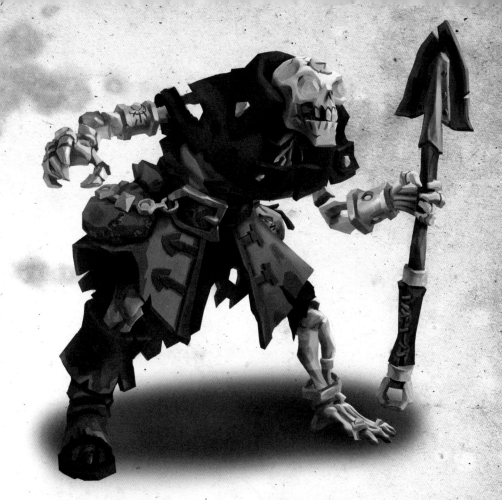

One such character apparently unknown even to my father is the Gold
Hoarder, a particularly terrifying Skeleton Lord whose name surely ties him to
the Trading Company I met, oh, so many lifetimes ago. This man's skeleton was
supposedly reclaimed by his spirit after death, driven by greed to the extent
that he patches up his immortal frame with jewels and gold. What a sight he
must be! Though I never wish to see it.

Ha! *Ha!* X *I beat you to it.*

SHIPWRECKED

The *Silver Blade* sank as the sun rose, which could hardly have been more poetic. As a parting gift, she left behind the entire contents of her hold, with ballast and barrels of fresh water left bobbing off shore. Everything but the chest, of course, which I had left locked below. It must be quite the drop where the water grows darkest. I imagined the figurehead, with its maiden and dove, descending into blackness. It is the last romantic thought that I shall allow old Flameheart to entertain. All of us have survived, but for what?

Even without a physical ship, my Blade lives on through its devoted crew that I can see stoking fires and returning from successful hunts. We are warm and dry, and soon we can eat.

Isidro, beside me, is staring into the heart of our pyre as Trouble rubs herself on his back, purring. There is something fluttering inside the blaze. Isidro took a kick at it, sparks flying.

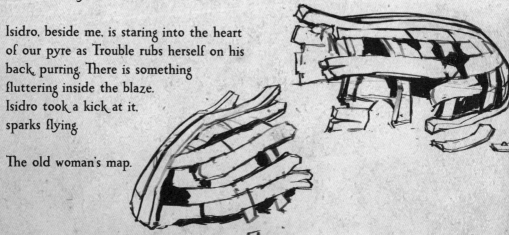

The old woman's map.

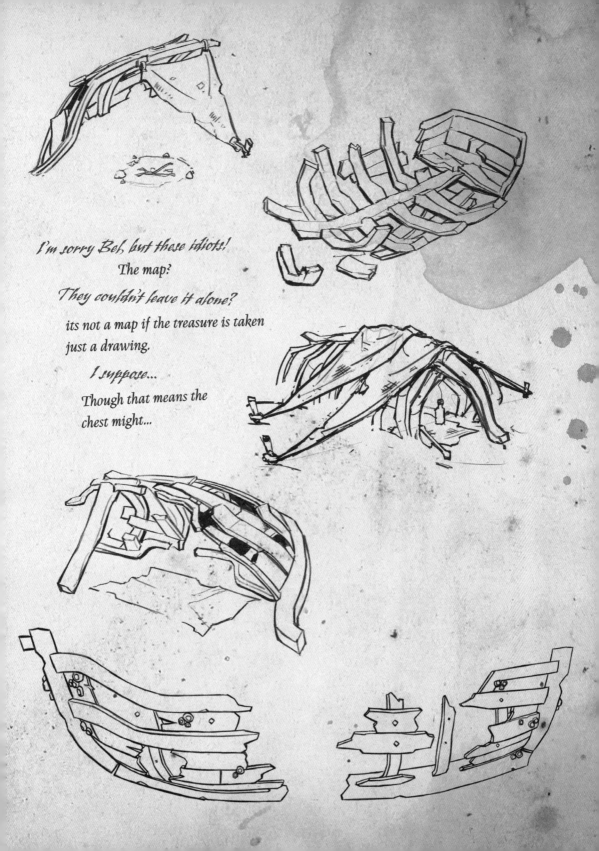

I'm sorry Bel, but these idiots!
The map?
They couldn't leave it alone?
its not a map if the treasure is taken just a drawing.
I suppose...
Though that means the chest might...

WHAT A PIRATE DOES NEXT

I feel no shame in declaring that my first voyage has ended in failure. Were there to be a tavern on this accursed island, we would now be drinking a toast to the *Silver Blade*. And yet I know that Flameheart the Scholar, the man who began this journal, would not have been able to raise a hearty cheer to accompany the swinging of his tankard. He would have moped, sulked in his rooms, berated himself for his incompetence and for having the audacity to believe he was capable of measuring up to his 'papa'.

That man, I am astonished to discover, is dead. I am a pirate, and I am a captain, and for as long as I have a crew that look to me for instruction (even as I look to them for guidance and advice) I cannot afford the luxury of wounded pride. We will return to the outpost, we shall spit in the old woman's eye for sending us after such folly, and we shall begin our adventures anew.

Still... I cannot help but feel that our voyage has been guided not by the lines of a map, but by the unseen hand of some larger force. Red Rosie tells me that although this region of the world is now sparsely populated and largely barren, there remain many treasures and trinkets from a bygone age when the seas sparkled; a time men and women claimed mastery over these shores. Those treasures may still linger even in a wilderness such as this.

If I am bold, and if I have the courage to seek it out, we may discover the true reason fate has brought us to this place.

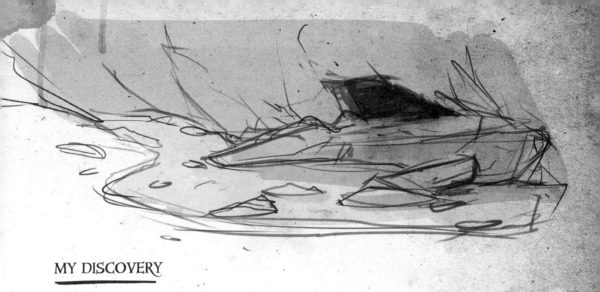

MY DISCOVERY

I found the remains a short walk from our camp. The flesh was picked clean, of course, but the mouldering bones were clutched, claw like, around an oiled pouch which time's ravages seemed to have passed by.

The riddle inside is faded with age and even I struggle to decipher some of its more archaic phrases. I am certain, however, that its meaning is somehow intertwined with this island.

The others agree, and tomorrow we will begin our search.

GOODBYE TO THE SUN

This island, for a distressing length of time, bore
no landmarks resembling anything mentioned in
the riddle, even after climbing the tallest coastal
rocks. Viewed from the sea, my flashbacks are
of a high walled, pincer-like bay which would
have defended our ship quite nicely, had we still
possessed it. What few pathways may have once
existed had long since been choked by the strangle
of vegetation.

We searched three days before one of us made
the breakthrough. More accurately, Tomas suddenly
crashed through an unseen hole, roughly the width
of two men.

He too had disappeared without a trace by the
time we had linked enough rope to descend.

There were others here, untold years ago, judging
from simple paintings covering the walls. Either
that, or somebody still alive is desperately poor at
sketching – more like scratching.

Shamefully, I lost the precious parchment as we
fumbled through the darkness, only to rediscover it
floating in a carved basin of the sweetest water. To
my delight, a golden chalice lay discarded at the
base. My first treasure! We passed the cup around,
drinking greedily, though even now it feels as full as
ever. We take turns supping as we journey on.

Red Rosie took a sip of the water, alarming us all at first. She is still joyful and
alive more than a day later, and so we are all now sipping from cupped hands.

Whatever secret this island holds, the riddle now guides us unwaveringly towards
it. The scale difference is considerable, but we have already passed through three
of eleven arches with corresponding symbols, matching those on the cursed chest
that went down with the ship.

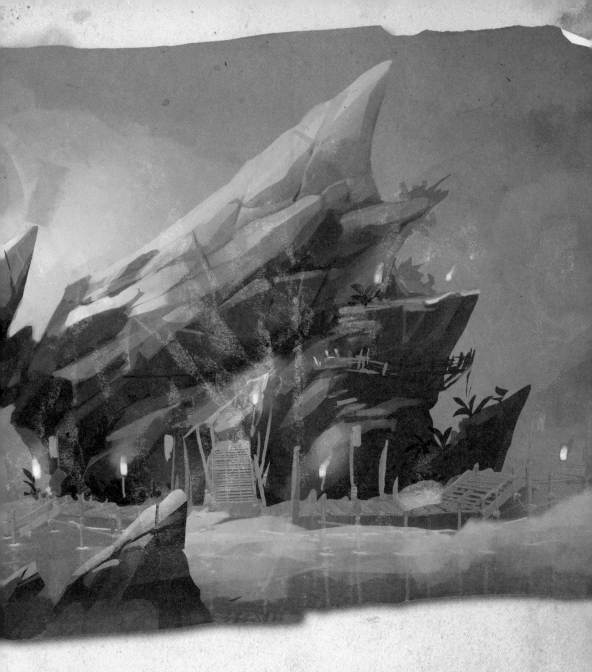

I have asked Isidro to translate. "Closer and closer, I suppose," he replied with
a cold smile. It is becoming chilled the deeper we go, but everyone is well
rested and watered. We must be getting used to marching on empty stomachs,
as nobody has mentioned feeling hungry. For the record, I am starting to feel
terrific. It is amazing what a little abstinence can do.

Was it the water that changed them? Or a curse on the cup itself?
Perhaps we'll never know.

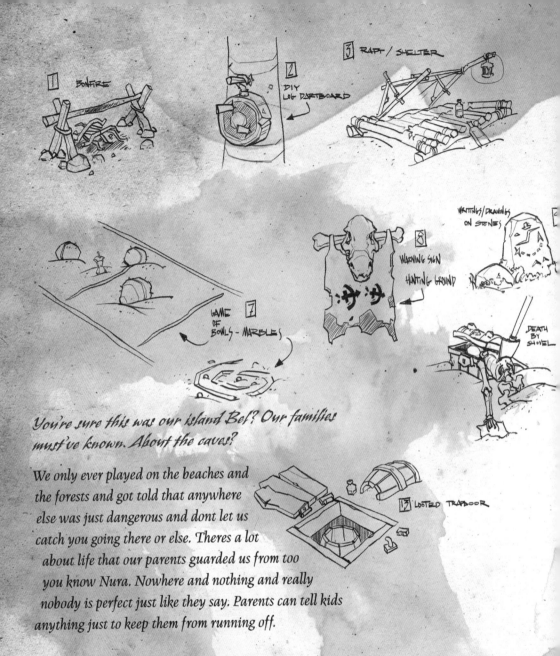

1 BONFIRE

2 DIY LOG DARTBOARD

3 RAFT / SHELTER

4 WARNING SIGN HUNTING GROUND

7 GAME OF BOWLS - MARBLES

WRITINGS/DRAWINGS ON STONES

DEATH BY SHOVEL

You're sure this was our island Bel? Our families must've known. About the caves?

We only ever played on the beaches and the forests and got told that anywhere else was just dangerous and dont let us catch you going there or else. Theres a lot about life that our parents guarded us from too you know Nura. Nowhere and nothing and really nobody is perfect just like they say. Parents can tell kids anything just to keep them from running off.

13 LOOTED TRAPDOOR

NEW CREATURE COMFORTS

We face what is likely the final decision as our trail carves further into darkness, away from the attractive portals overhead that have guided us thus far. Nature has trained our eyes to adjust remarkably well to the dimming light, so that torches are no longer needed. Blankets are now sufficient to keep us warm by night. Isidro has kicked off his thin cover to sleep like a starfish, and seems fine. We should carry on exploring, then.

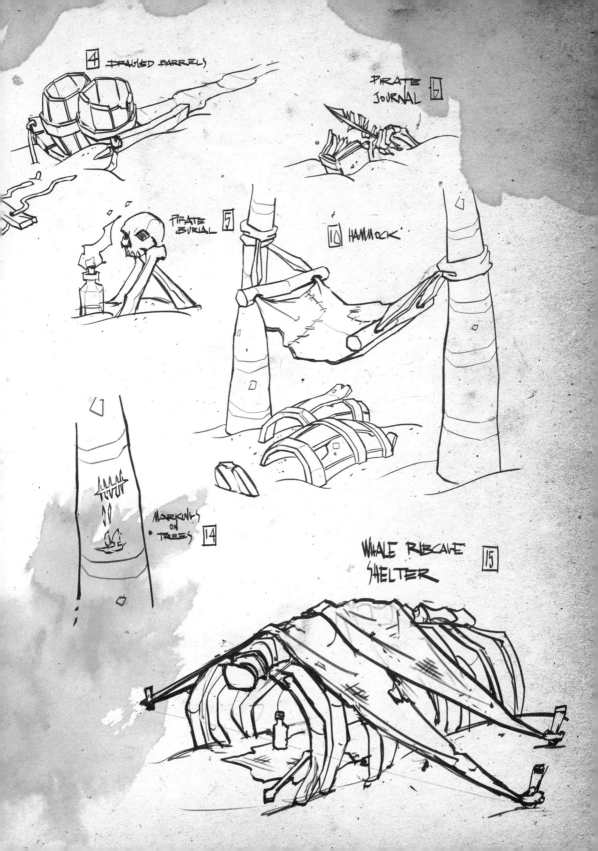

A PROMISE TO KEEP

Contented, the crew no longer questions the lack of coin or trinkets that
we surrendered to song at the surface. The most precious commodity is the
delicious cool water that flows unceasingly from my chalice and swills down
our throats, sweeter than wine. We have discarded buckled shoes to stroll bare
footed through glassy pools, unavoidable.

We do not stop to drink. We are drinking as we walk.
There is laughter as we gargle and spit.

Sometimes when I wake up, though I forget if I decide to
sleep, it feels like people are missing. They'll be fine. Like the
riddle, which is somewhere, everywhere, whenever I need it,
those of us that are absent will probably be there to greet
us around the next altar of bones.

Living walls appear to motion us forward. Men,
women cheerily wave and smile back at the shifting
formations that shimmer with dreamlike pastel
shades. We should be arriving soon; it looks like
there is a welcoming party ahead. I cannot tell
you how happy and relieved I am
that the *Silver Blade* has, in the
end, delivered us safely to our
destination.

I cannot... I... am...

FLAMEHEART?

And as for me, as for this book, it
has almost begun writing itself. I
am Flameheart, and these are my
words, but this is not my voice.
Though, I sense now that it is who
I truly am.

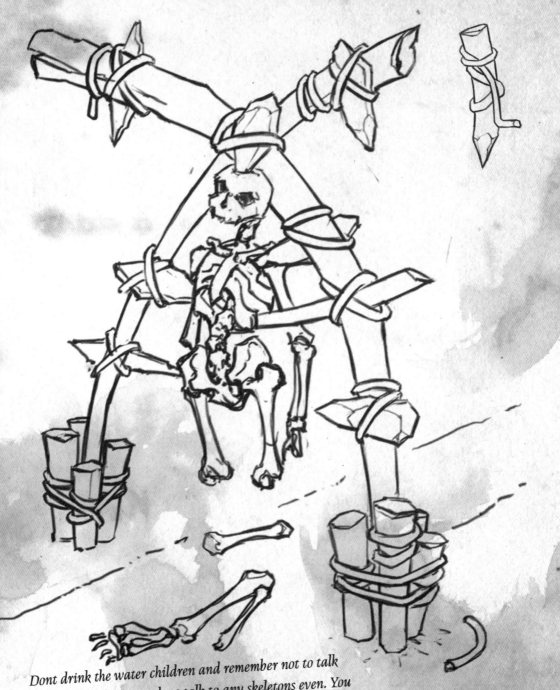

Dont drink the water children and remember not to talk
to strange skeletons or dont talk to any skeletons even. You
know what just play on the beach or no grandma cake.

He's losing it. Bet we are never going down there.
I don't even want to see our island again. Well I had been thinking.
Just no, Bet. I'm serious.

I shall now politely describe what I see before me, because this is what he wishes.

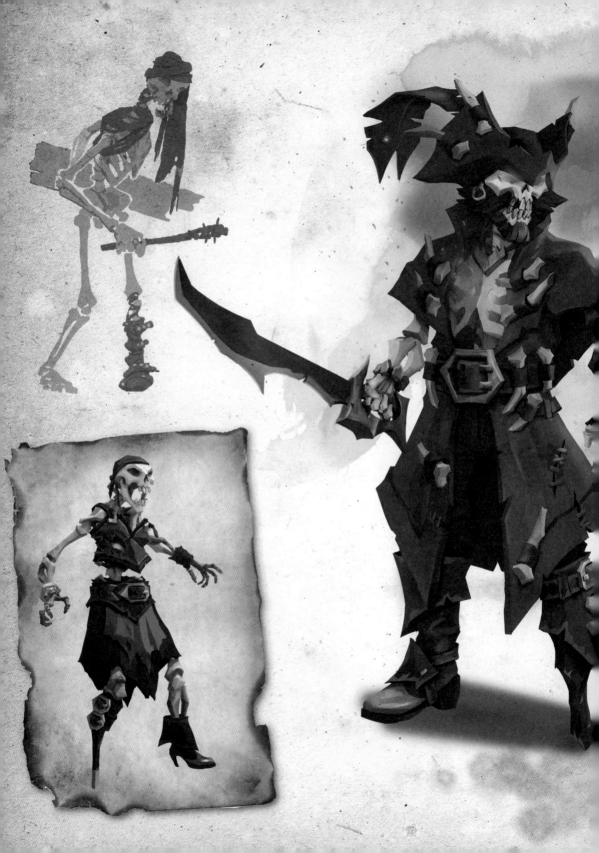

PIRATES, FOR ALL ETERNITY

To spend forever with my crew. That is my reward. And they are all here with me, bowing before The Cap'n. Here, I should explain, is the coldest and darkest of caves whose size it is only possible to guess from the tiny shaft of light that begins several hundreds of feet above us.

The Cap'n, I beg of you to believe, is a walking, talking skeleton. Yes, he has heard talk of the Skeleton Lords, and would look forward to crushing their bones given such an opportunity.

It was the Cap'n that invited me here with his riddle. He left his golden cup for us to take, trusting that we would drink and thus in time become enthralled to it. To him. I would say he looks extremely happy with the arrangement. As for the crew and I...

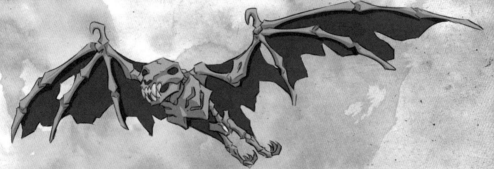

Only I have been awoken from the rapture. Only I see the truth of our present circumstances. And only I can decide if this spells doom, or deliverance. But, in a nutshell, we are all quite dead and disintegrating. Also, extraordinarily hungry, although soon I shall not have the stomach to eat anything much, in fact no stomach at all, nor a heart, nor...

Well, The Cap'n has done a very fine job of outlining the benefits: we shall enjoy eternal life, pursue endless adventure, reap untold rewards and never once need to stop for our dinner. Humans will be terrified of us but this is only to be expected. Not all of them attack on sight.

Did I have any last questions? "Why me?" was the main one. "You remind me of your father," the Cap'n said simply, "A fine crewman, 'til he stranded me here. Perhaps you'll make an equally fine replacement. Follow, now..."

Did we return his faithful cat? Yes, I believe we did.

Just dont judge me until youre finished reading the whole thing okay Nura?

Sure sure sure...

DAY ONE

In case something happens to me I am gonna write all this down and in case anyone else finds this old book before it gets to Nura, my name is Marisabel – Bel for short. First I am not a writer. I mean I can talk but I dont write more than I have to. Like now. Obviously.

I think I might be onto something important. I will tell you about it Nura but not yet. When it is safe. But if something has happened to me like I am gone okay dead this isnt goodbye. We said we would never say goodbye. I remember that.

So on the brighter side theres this guy here a dead guy. A long time dead guy like I mean he is a skeleton. His bones are here on the beach we've been partying on since we were little when our folks would bring us here.

Trying to figure out what happened to him like he got killed somehow in this magical place? And he was holding this book. The one Im writing in. Its supposed to be his captains log and its kinda hilarious but sad too cos he seemed an alrite guy. But its the thing that got him killed thats the thing.

Maybe this place is more special than we thought. Than anyone knew I mean. I am gonna read some more of his stuff and write down what I find and what to do about it.

DAY TWO

So anyhow Im back on our little island at the beach with Mr Bones.

He was another one of those wealthy guys with nothing better to do than to try and be somebody else somewhere else because he was bored. But to give him respect I will at least say that he did love the sea. I think he did genuinely understand something about the likes of us Nura. He really wanted to be one of us so I honestly like him. Whats left of him. Ho ho.

It wasnt about the treasure * hahaha * you know the famous pirate treasure that we all have lying around someplace. Anyway he didnt get into it for that. It was the life. Too bad he had to die so soon over it. But Mr Bones could be a legend. He found something big. Real pirate treasure. I know. Stupid right? Maybe a joke. But I don't think so. I know about people. I know Mr Bones (his name was Flameheart a nice name) was writing down something he believed. He may have been an idiot but he wasnt crazy. Or the other way around.

Mr Bones and his entire crew were cursed. Like a big time curse you hear about in stories not just a bad luck charm or like a chest that makes you sick or something. Okay reading some more of Flamehearts stuff here.

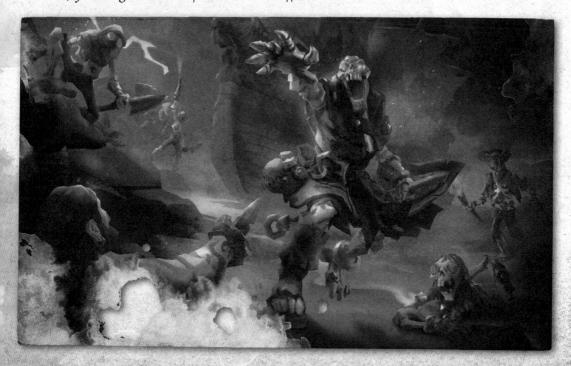

DAY THREE

I have to say I have been laughing so hard. I havent laughed so hard since the day we were married. You know how funny that was right. Funnier than that but maybe important.

Whats funny is that if Bones had cared about the money hed have gone to work for the Gold Hoarders and he might even still be alive. But instead some weird old lady put ideas in his head and sent him out this far. What he says about her moving tattoo makes me think she was from some crazy lost artefacts group, you know always after some relic or other. And a million things could have gone wrong for him but he was lucky to have a good crew and that's what counts I suppose.

I stopped because I was just laughing again. Its too funny. So they actually get the treasure and some other ship starts to attack (probably the old woman thought they were sunk and sent another crew for her precious treasure or maybe just bad luck) and Bonesy decides to be clever and hide. Hide in the devils shroud!! Everyone, like everyone, knows you stay away from that mist. No one comes here when its like that. But on the other hand his ship could still be nearby down there.

Strange that nobody around here never spoke of stuff going on here. Stranger if somebody around here even knew about it but didnt wish to say. And if my dad knows about it there must be a handsome reason why he has kept such a big lid on it.

I know I know Im thinking too hard. Thats what your thinking right?

Going for a swim.

That is what I am thinking and I am right.

You mean when we were cryin after it was the first thing we said we wouldn't do?

Every time I woke up I didnt know if you were laughing or crying because the bed was shaking. It was you or me doing it the whole night so we looked like crap next morning.

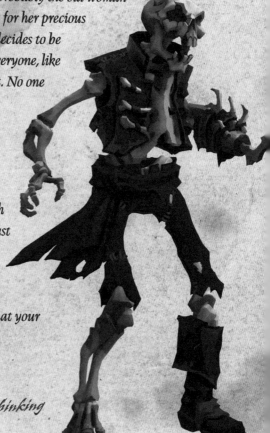

DAY FOUR
The Sea of Thieves...

Or, don't go for a swim because like you already said about the Sea of the Damned... and... you went anyway. Terrific. Thank-you, you know how much I love yelling.

Thats what they called this place when pirates first started coming here as if everyone here is just a criminal or a coward. I mean sure there are people like that around and you shouldn't ever turn your back on them or stop if you see them in the water.

You need a strong crew and you have to be in it together. You dont just pay people to work for you. You earn their respect so that you can work with them. That goes for every day things like not crashing the ship into a rock and weighing the anchor but it also goes for the big things. Or perhaps Nura and me got too lucky. We got lucky being together. Like chosen ones.

I may be risking a ride on the Ferry of the Damned but what if there is treasure down there?

Went for a dive. Found the wreck. Definitely something... off.

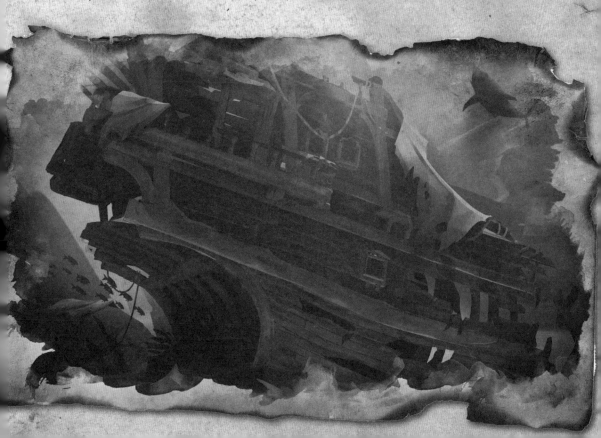

DAY FIVE
This isnt right.

Bones ship ... whats left of it which isnt all that much ... is off where we all learned to hold our breath as little ones. Me Nura and other kids from our parents ships.

We were lucky they let us sail with them thinking about it now... a lot of pirates wont allow kids on board. Maybe Nura had seven summers behind her and I had maybe six. She was older anyway and acted like it. So bossy. I think she started to like me though because I kicked her butt so many times on that beach. Anyway this big broken up ship is slowly rocking there just before the drop off where it gets very cold and dark. Which is usual I know. Usually.

What isnt all that usual is that it is so dark and cold near that ship like winter. I was shocked out of holding my breath and that never happens. And Ive seen some things below on these swims of mine... like I should probably write some of them them down in here. Like Bones. Yeah I dunno.

Flameheart had said in this book that hed locked the chest down in the brig in case it was cursed. As if that would matter! Like a curse can be stopped by an iron bar or a chalk circle or some incense. Ha. So first I had to find the key.

You see, this is where anyone else would stop. Just, you know, stop.

And my answer to that is....

"I'm not anyone else Nura", which is fine when it's drunken fools we're taking on, but not some cursed treasure. Apology not accepted.

After three dives checking the captains cabin and the middle deck I suddenly had a thought that hed be the kind of guy to always keep his keys on him so I went back to the beach where Id found him with this book... at least I thought I did but it took me another 5 minutes walking to find him again... weird.

The key was on a gold chain around his neck. It looks pretty on my wrist. The water in the brig was coldest of all and for once it made me wonder if the crew had been right about some sort of curse but the chest was right there so what kind of pirate would I have been not to rescue it?

Maybe it was just the water but at times it felt like the chest was making a noise I could just barely hear. I pressed my ear right up against it on the beach though. Nothing. Good.

I know I probably should have left it behind. Nura will not be happy.
Sorry Nura.

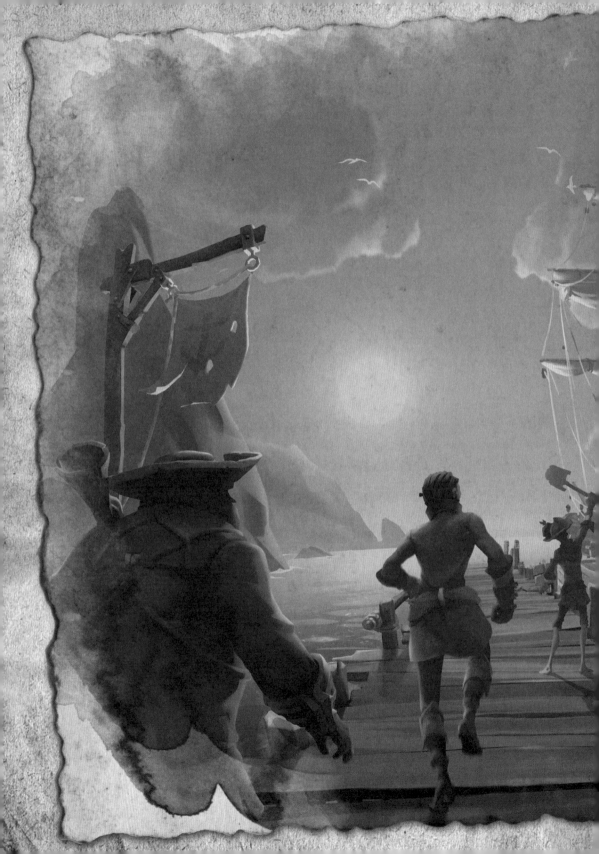

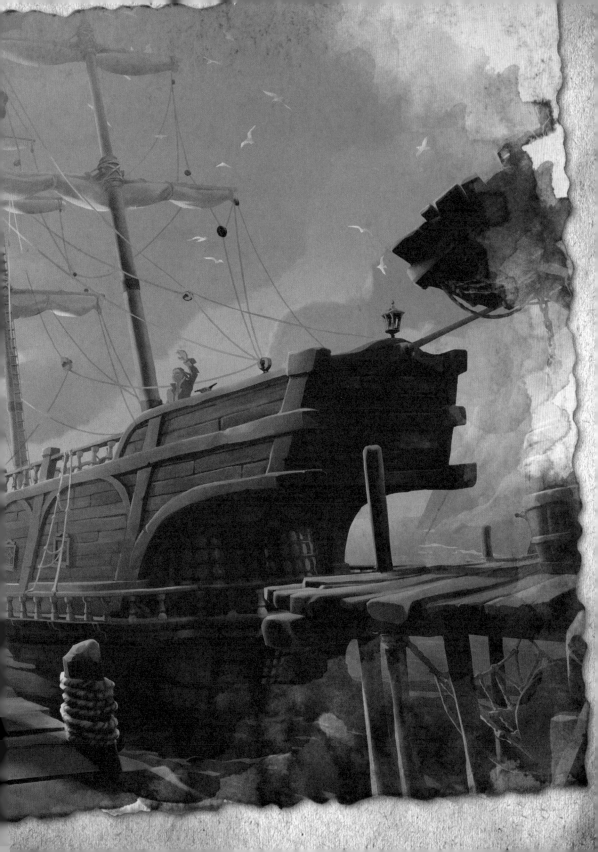

DAY SIX

Thinking about Bones and his crew has got me lying awake. I dont mean because Im spooked or creeped out, we have all seen a lot worse, but just kind of... thinking about life and death I guess.

Guys I know have been there and come back good as new if not better in my view. The Sea of the Damned I mean. Its a good name for a really scary place and I guess that waking up on that boat and hearing those noises gives you reason to stop and think.

They say that death used to just be death. A one way trip. No ferry no way back just lost forever in that place. And then the captain came with his Ghost Ship and his door and gave us all a second chance. And a third chance and a fourth chance. Maybe one time therell be no more chances.

Or maybe there will come a time where you say to yourself that youre just going to stay because its easier or because its your time like youre old enough and have lived your life. But knowing that we can always come back from there – to continue and learn from our mistakes – is a lot of what makes us stronger as people. If you do learn that is. Some idiots just dont and even if they crawl their way back theyre just no good to me and this crew.

To me its like onions or garlic or whats that stuff– tastes like crap? Doesnt matter. Anyway its like that. Some things you cant stand when youre little but when you get older you dont mind as much and then when you get really old you just seem to end up liking it. Maybe people get bored or forget they dont like certain things very much. So you end up with it and the little ones think theres something stupid about being old – or just older.

The Sea of the Damned is where you dont want to be for as long as you have something to come back for. Or someone. Like nura.

Hopefully Nura wont ever be that mad at me that she would just stay to teach me a lesson. Im worth it arent I? We are worth it. Im always coming back. Thats if Im ever gone. But Im just too good. Ho ho. Im always coming back for her is what I mean.

But then those who didnt or wouldnt leave find a way back sometimes. The Lost Souls floating around in the Sea of the Damned can sort of slip through the cracks between the worlds. Me I think it has something to do with how we remember them like our memories make some sort of bridge that you can cross. Who knows though? I have strange ideas.

Anyway thats how we get ghosts and that's how we get skeletons… at least that was what Dad said when we asked him about it as kids. He says he got in trouble for talking to the ghost ship crew about it all one time. The Captain didnt like that and nearly made old Dad part of them!

Ghosts are no trouble for the most part and sometimes you cant even talk to them. Its like theyre just a sad echo you can see as well as hear. But sometimes those lost souls dont stay lost, they find there way to some old remains and take them over. Skeletons can hurt you and they usually will until you destroy their old bones.

I think – no I know really I dont know why I put that. I know Mr Bones back at the beach ran into some ruined old souls. Skeletons. He isnt dead. Ill tell you how I know but first I want to ask myself if all skeletons are bad news because… okay I wanna call him Flameheart now. Flameheart, a nice name really, was a straight up guy and if hes back it cant be so bad.

He wasnt all bad news before. He could be a good skeleton yknow. Yeh I know. Stupid.

Anyway the reason I know Flameheart is back in his bones is because when I checked again after finding his chest he was gone from where I found him. Where he went? Thats what we need to know. OK not we just me. Nura wouldn't want to know I know.

Well I didnt expect that you would eventually read this I just wrote it because it was like you were there anyway and I was feeling guilty about it.

Okay so here we are on the same page now though not really on the same page at all. But now that I do know, I do want to know. Falstheart became a skeleton. This gets better.

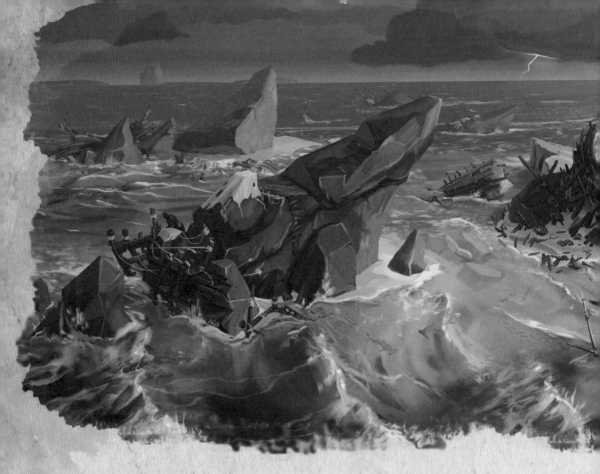

DAY SEVEN
Shipwrecks we have plundered!

Going down to the Silver Blade like that made me remember some of the times weve had. Diving I mean... I know that for all of us the whole business of sniffing around sunken ships is a thing that we all just ynow do. Im pretty sure we are among the only ones doing it for fun though. And to stay rich of course. Yeh and just to prove I'm really something blah blah!

Also my disgusting and terrible beautiful and intelligent wife has found my book so the jig is up. Haha. I feel bad about keeping secrets about curses and treasure. I do. But hey look wow look at all these times we had where you werent so sore at me! Nura do you remember the first shipwreck we snuck into? Our 8th summer. 9th? No 8th! You were still really tall and skinny. You used to call me bear, which I didn't like.

Have to say I'm seriously considering bringing this back. But bears are never this stupid.

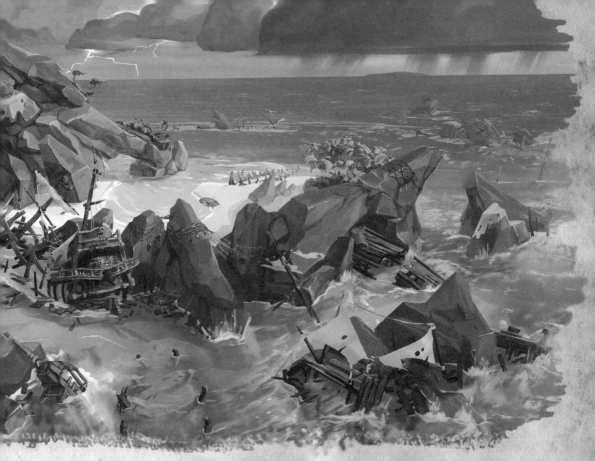

So that first wreck wasn't really a wreck after all. I mean it was certainly a big mess but we found out that it belonged to Captain Truewalker – after she found us going through her things and blowing the dust off it all putting her things on and working to clean the spots off useless pieces of paper with stones by the shore. They were her treasure maps or some big secrets eh! We did get them clean though.

Probably the first time my Dad ended up dropping by the Sea of the Damned. Yeh he didnt even pretend to like it that time. Him and your dad... no wait your mum right? Your dad said no. So they had to go down and explain everything to Truewalker. Like Oh yes it was all a mistake you see... ... sorry Im just laughing here. It was all a mistake Captain our daughters thought your ship was a wreck you see. Our daughters did. And... oops dead!

Oh Nura! It was definitely your idea. You said it was far too messy not to be a wreck.

Although I despise taking the blame for all your misadventures, in this case I think you're probably right. But I do despise always taking the blame. Just so you know.

Yep. Fine.

Toy treasure

Like all kids I spent every summer from my 12th summer – I think – being taught how to dive for sunken treasure. We were put into random teams of 6 with capns masters and the rest as crew. I was capn of our team because it was my Dad running it. The other helper Dads volunteered their kids too but I was better than all of them. And I proved it Nura.

This was honestly nothing like diving for sunken treasure which I told my Dad later on when I was older and he agreed. After I punched it out of him! Just kidding. The treasure was all brightly colored wooden toys my dad had made weighted down with rocks on pieces of string. Little pistols. Tiny cannons. Cute pirate dolls and pretend coins. It was like swimming in a small warm bath and by the time I got older my bum was poking out of the water in some areas because it was that shallow. Like it was 10 feet if even. When your little though it could seem deep. When your scared of running out of the air your holding.

Maybe this was the real point?

We all had our own little area to bimble around with the same red yellow orange and green painted 'treasure'. To make it more interesting for myself and to challenge my team we would go after the others too. We were really annoying and some of those kids still wont look at me even now. I could see that my Dad thought it was great though.

Not even he knew about the earrings. Well he saw them and said how much he liked them but I wanted to keep it a secret what they could do. Somebody must have dropped them in the shallows who knows how long ago. And maybe someone spotted them before I did but didnt pick them up because they dont look like much. But not to a kid. And now this kid is a grown up that can really talk to merfolk. But thats always been our secret Nura. One of.

I have my moments. You have them a lot. *Don't get creepy.*

Real treasure

I always think back to this training and all the things it didnt prepare us for like
that time we went into the captains cabin expecting to find some chests or a few
barrels at least and what we found was a very big and very angry shark that had
somehow managed to lock itself in. Captain shark! I still havent heard any one else
talking about that spot so for now I think we dont need to challenge anyone for it.
But it was a brilliant idea of yours to scratch the boxes with my signature meaning
Property of Diving Bel Steal at Your Peril.

Anyway that stuff has my name on it and they will know or they should.

I even think it might be a good idea to sneak out the word somewhere in case
another crew figures out how to recover it all. We can watch them do all the work
then remind them who it belongs to. I think this is a great idea – mine by the way.
Glad I wrote it down!

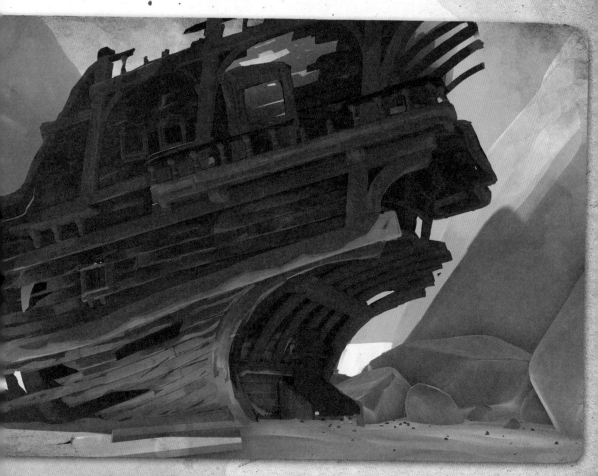

<u>Skeleton Treasure</u>

This one we almost died. All of us. The whole ship and I take the blame but I also take the credit for everything being fine in the end. We knew of this site where something big had gone down years ago years before our time and maybe our folks time before that. An old fort not like a castle from a book of fairy tales Flamehearts Dad might have read to him not even made of stone but spiky logs smashed into the sand so stop ships getting too close rickety platforms up the side of the rock face and cannons for defense. An old battlefield.

Even getting to the fort almost killed us because we got caught up in a real nasty storm so we were all tired and soaked and not thinking clearly. I guess maybe we were a little too hasty or arrogant but we sure werent expecting those cannons to light up as we approached. These skellies had gotten more clever than most and were actually firing at us! Well since I was already wet I just dove straight overboard and Nura kept the ship juuust out of their reach. The first one never heard me sneaking up on him and the others didn't like the taste of their own cannons ha!

How do they even see to shoot with no eyes? Feels like cheating to me.

Thats your only concern??

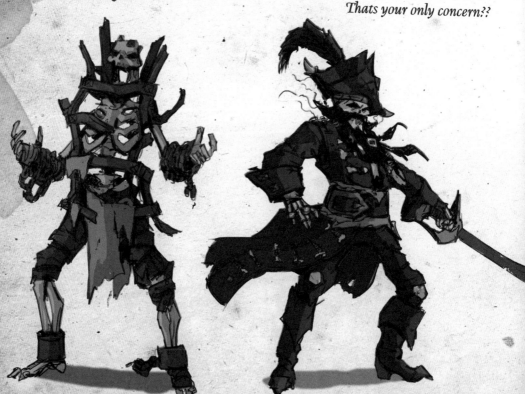

Other treasures

Sometimes if your really lucky you will find yourself sailing home with a hold full of treasure from wrecks and forts and islands, and then just to make your day even better youll spot some barrels of salvage just floating along on the tide. They normally dont have treasure in but can still have useful things.

But you know not all treasure is useful to a pirate and when that happens its best to head back to an outpost and find some moron helpful merchant to take the chest from you. Like if its locked you can give it to the Gold Hoarders or if its some old relic you found there will always be someone who wants it. Even if you caught some hideous fish thats no good for food someone will buy it.

If you happen to have "found" some cargo you can usually find a smuggler wholl take it off your hands but you didn't hear that from me.

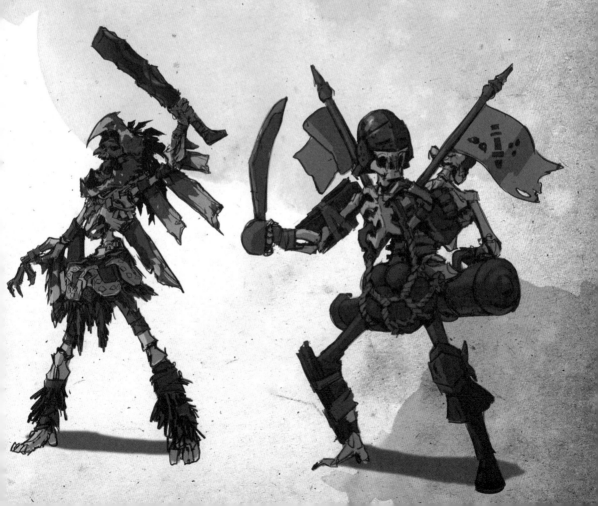

DAY EIGHT

The chest I rescued from the Silver Blade hasnt made that high pitched noise again and Im starting to think I was imagining it. It has weird writing on it too and Im not surprised even someone like Flameheart wasnt able to read it. I cant read much of it either but I know what the language is and I recognise one phrase... "Do Not Open".

~~Does this mean its a merfolk chest?~~

Ive seen a few cursed chests in my time and they don't come with warnings. A curse is like a trap, its something that very old and clever pirates (I mean old like our ancestors not like grey hair and farting all the time) which means that at some point whoever looked in the thing realised what was in there was seriously big trouble and tried to make double sure no one opened it even if they found it.

Or maybe whats inside is dangerous to merfolk and thats why its in their language and not every language.

I know what youre thinking Nura and you would be right. If Im not going to just bury the chest again and we both know Im not I should just take it straight to the nearest outpost and find some old kook to sell it or use it as a footstool or take it to a museum far far away from here. And normally thats what Id do.

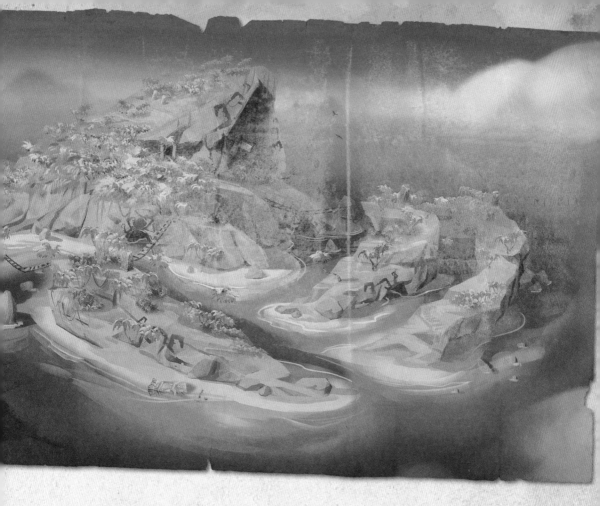

But first I want to know if whats inside this chest is worth it for us. How valuable it would be to the right person. This could be it for us Nura. The big haul. Enough to make us legends even when were old wrinklies together. I need to know.

So you will not like this at all but for now I want to plot a new course to where the merfolk can be found this time of year. Not the stupid ones who follow our ships around and save us if we fall overboard but the ones who actually run their world beneath the waves that we never see. If anyone knows whats in the chest its probably them. And Im the only one who can ask them about it but that is our secret so I need another reason to convince the rest of the crew.

This is me apologizing to you for putting something past you and hoping you will look past the craziness. You cant worry about this and I cant worry about you worrying about it.

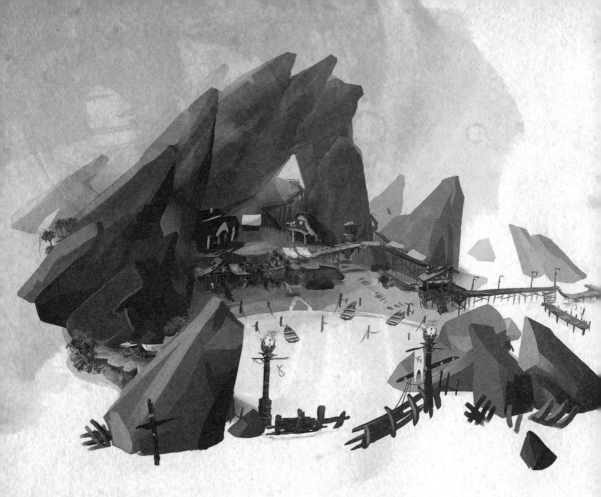

DAY NINE

Awe. You are very welcome Bel x

Praise you for keeping everything in such good order Nura. Your books tell me that the mer are most of the time moping around not far from that old outpost Golden Sands. If Jean is looking to boost his galley skills theres folk from all over at Golden Sands to give him ideas. Pretty sure the others wont mind missing out on fishing to let their hair down either. I know you dont enjoy the place the way I do but I wont go looking for fights. Ill make an excuse for us to watch over the ship but I won't tell the rest of the crew whats happening.

I will go for my swim to meet the sun same as always. As far as the crew know Im straightening my head out and getting my blood flowing ready to be leader another day. Ill remember to kiss you when I get back soaking wet because you always complain about me doing that eh.

The world below is honestly beautiful this time of year so no wonder the merfolk make it their own for a few moons. I could even tell the others I bumped into some merfolk... or maybe not. Better not get them curious about anything.

This is my plan Nura

Tell the crew we are going to Golden Sands to stock up and relax and party if they want

Talk to Jean about his recipe book and tell him a few people to speak to like its his big chance to load up with the most incredible grub in the galley.

Swim out to the merfolk and tell them about the chest and what I need to know in return

Ruins of that old fishing village a short haul from Golden Sands is a good place. Not great but.

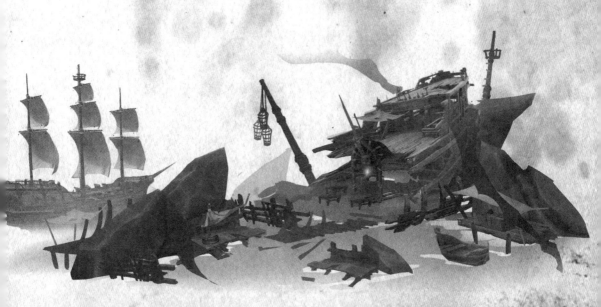

DAY TEN (EARLY!)

Years and years ago that island wouldve been really something. When it had a name and people to care about any of it. Clever people who knew how to build and make it last. You would admire it too Nura: the bridges connecting mountain ridges overlooking temples to some freaky looking gods that I didnt know people thought existed let alone had names.

These were people that spent a lot of their time below. They probably looked to the merfolk for help in a lot of ways. Could even have been the first people to have ever met the merfolk and figure out their creepy minds. I wonder what kind of deal was struck to keep mermaids around whenever pirates run into trouble? A sort of I scratch your back you stroke my scales kind of deal or something not quite so friendly or even pretty dark which wouldnt surprise.

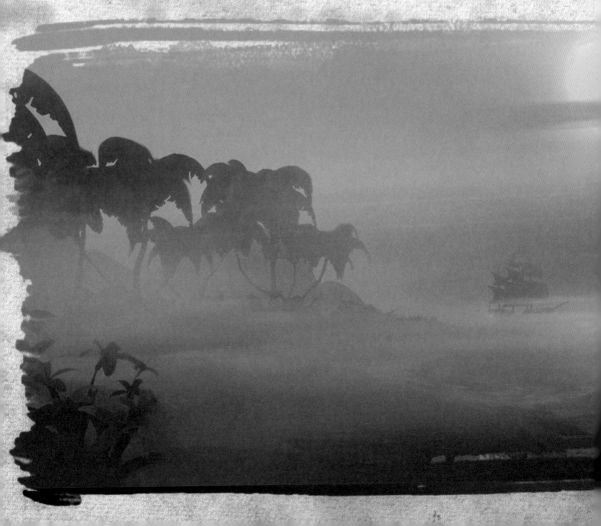

Well thank you to those people from long ago for sorting all that I suppose. Makes me feel humble. Yes definitely a proper place to hold an important meeting with merfolk elders.

I headed to the far side of the island to see if there was any place suitable like maybe even a place the ancients wouldve chosen to smooth things over with the merfolk way back when...

I was right Nura! A coastline temple has a ceremonial chamber built into it and the whole thing set up to make it feel nice and cozy and flattering for any merfolk visitors. If I were a merperson I would be so moved that I would be throwing treasure at the humans. Here have more treasure!

Maybe it wasnt just about the treasure back then. Havent felt this silly in a while sorry.

I climbed to the top or I think it was. It was high enough for me Nura. I could see our ship and the outpost waking up. Down wind I thought I could hear you shouting at the crew.

So I swam like the wind to get back. Didnt want you shouting at me in front of everyone.

Also I needed breakfast inside me.

The horizon was misty when I left. Something tells me the Devils Shroud may swallow this place up soon. Who knows when we will be able to come here again?

DAY TEN (LATE!)

You were already sleeping Nura so you
wont mind me going without you.

Well I went sooner than planned
because I couldnt sleep so why not just
go.

Those ruins on the island outlined
against the full moon were beautiful. I
mean beautiful. The water is warm and
calm this time of year so swimming felt
like flying in the summer air.

Right again Nura! The merfolk had
gathered in the waters below this island
so it saved time looking for them really.
I could just follow their song and swim
to them there. Ha! So easy.

I had their attention. This temple by
the way continues all the way down
to the merfolk meeting spot they use
this time of year. It is so much better
preserved down there like I was swimming back through time the closer I got to the
lights.

Two minutes there and two back. They had really thought about this whoever thought
it all up I mean. I had just enough time to leave my earrings which will be like a
formal invitation in what looked to be the appropriate place. All this ceremony!

That whole island seems healthier by moonlight the ruins especially. You have to
know that it is all misleading though like you can still fall and smash your skull no
matter how gorgeous and perfectly blue everywhere looks. Sat for a while. Listened to
the breeeeze in the treees.

Caught the shivers which was my cue to return to you. Anyway shadows were playing tricks on me. Maybe this whole curse thing is getting to me. Swore I saw a distant island that wasnt there later even haha.

Gonna be fine. Finish writing this. Get some rest. Get the chest. Take it there. Have a chat. Be extra nice. Work things out. Done.

Back in our cabin watching you snore. Good night Nura. Tomorrow is going to be fun. Or not fun at all. We shall see.

PS Good morning Nura x *We can only hope.*

DAY 11

I was looking through books for notes on merfolk and I found this old poem which I carefully copied out. A lot of it isnt true but it is funny how people think about mermaids just because they cant understand them.

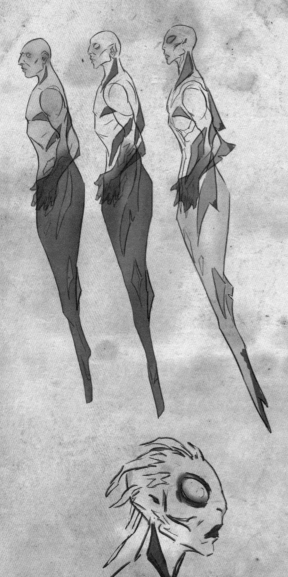

Don't linger in the waters
Where the merfolk are at play
The ocean's sons and daughters
Will lead our kind astray.

Though many is the sailor
Who has found themselves on land
After meeting with a strange Mer
That they could not understand,

It seems they care for no reward
For tender ministration
When we have toppled overboard
In our inebriation.

But if it's you they've chosen
They'll surround you with their kin
Your legs are bound and frozen
In a wrap of silver skin,

Soon you'll be understanding
All that passes from their tongues
No food you'll be demanding
Nor fresh air to fill your lungs,

And they'll take you as their brother
Or their sister as they please
And you'll be just another
Of the merfolk in the seas.

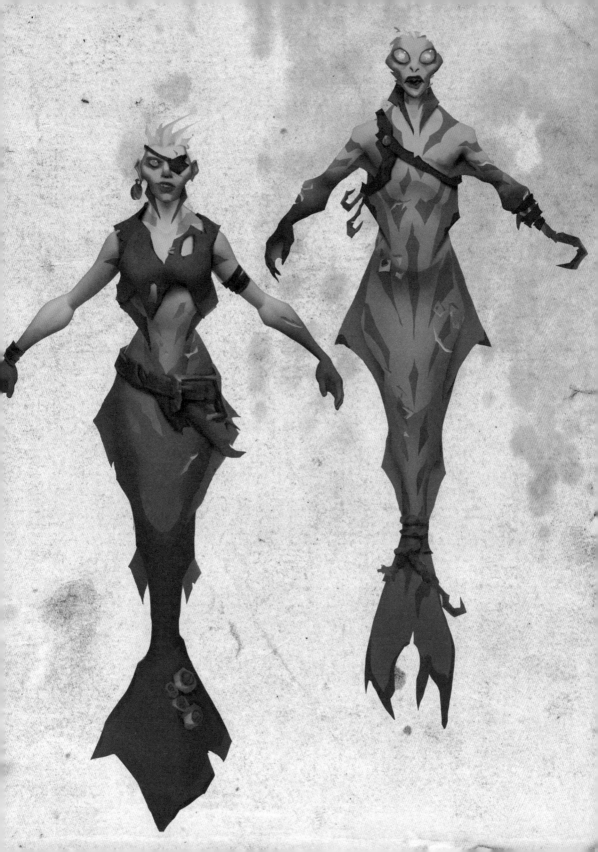

Well I will say this about the merfolk and that is there is never a meeting that isnt somehow fateful. Like it draws a line under everything and draws another line leading to whats next.

The crew are rightfully extremely cross with me for making plans without them knowing and in it isnt only because I am usually just telling them everything because they need to know. A cursed object is much too big a thing to not mention. They deserved to know which they do now anyway but in this case I wanted to wrap up as much of it as I could on my own.

And having a thing that you are going to do which might need to be done with somebody else is not a plan like you always say and I get it.

After the boat trip to the island was made in almost complete silence apart from a couple of the other guys humming and whistling no particular tunes we did good before the merfolk. Well I did. But I could see that this conversation was bothering the others especially Jean owing to them not knowing about my secret. Which is why its a secret of course

The mermen... the older one especially ...looked instantly furious at the sight of the chest and no they did not want this on their hands but it was worth trying I thought hoho! They did say not to open it. I have no intention of ever opening it. We should not drop it back in the sea though since thats not what the merfolk want and hey we all want happy merfolk.

We were brave or stupid and I prefer brave for coming to them with the chest and a bunch of awkward questions. The worrying part I agree Nura is that the mermen were so miserable at the sight of it. Like it is serious big trouble of the kind you cant talk your way out of. To make matters worse the chest started making that

noise again and that was basically it for the meeting they all hissed and fled like it
was my fault. I must say I got kinda spooked and almost forgot to take my earrings
which at least they gave me back so maybe there can be a next time.

If the chest really is bad news Im starting to think we should only keep it until we
find someone who will trade for it. So we lose it another way like my dad would
say through hardwork and sacrifice and so much grown up seriousness. That I or
possibly we all lose everything. Left with nothing.

Everyone was quiet on the way back. You held my gaze this time though. The
whole way.

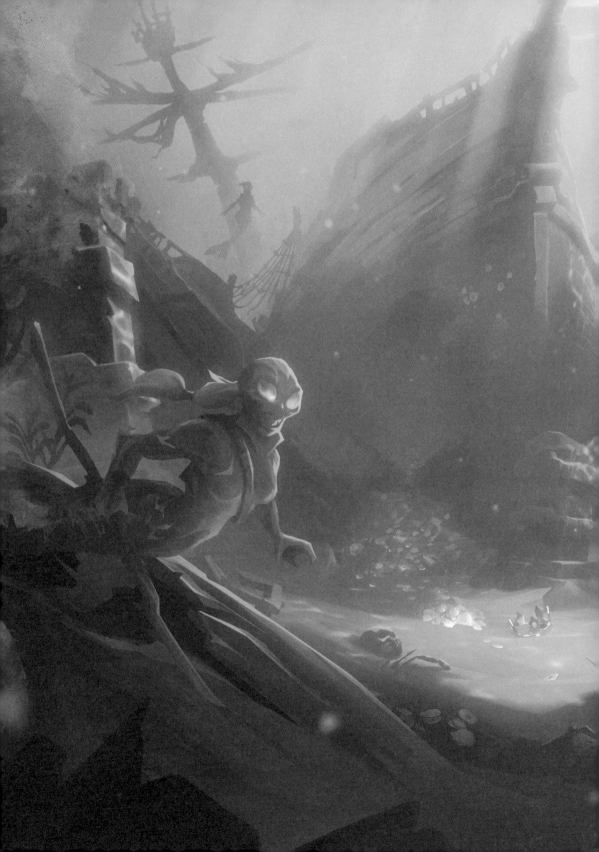

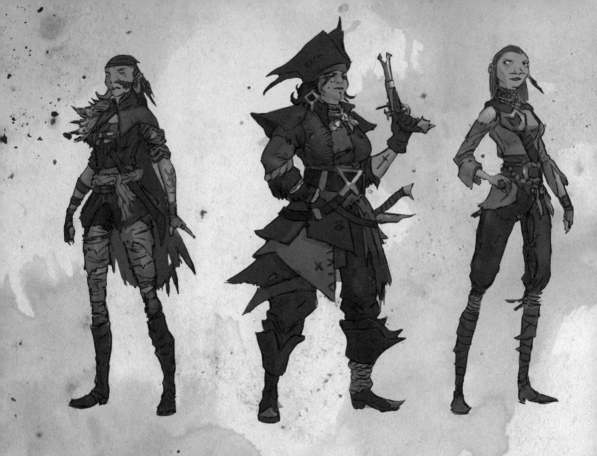

DAY 12

Well Nura the crew is not pleased about the chest or *This was a surprise?*
how I lied so have been sulking a fair bit. *It was.*

We need to keep our family happy so Im gonna suggest we give the ship a refit
then go looking for easy treasure. I think this trip out on our sea will be a good
thing for all the crew Nura I really do. We have been sailing mostly untroubled
for a while hunting for ourselves with few willing to risk challenging us. So lets go
make trouble and some money more than likely.

Gotta spend some first though Nura. Not much near here is worth buying or
stealing so were off to trade with some of the merchants and dealers around
elsewhere. Im sure we can charm some Company fool into striking a deal for this
or that. Maybe even a treasure map. But of course what we will really be looking

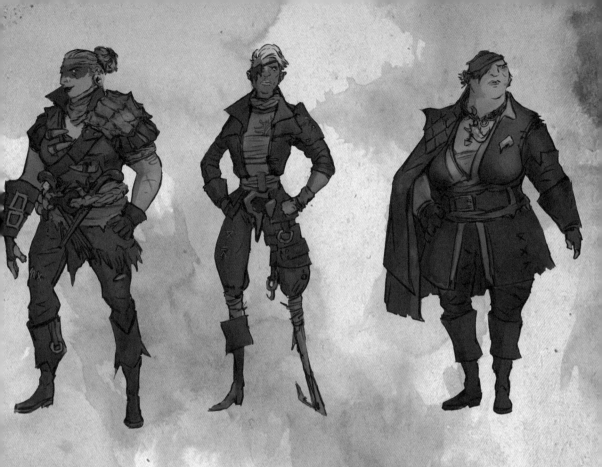

for is someone who we can scam into taking the chest. If I just bury it somewhere Ill look like a fool but if we can get coin for it the crew should forgive and forget. Even if I never find out what's inside the damn thing.

Whatever we bring to the table we should also have Jean rustle up one of his specialties because most pirates I know think with their stomach and it will make them think more highly of our trash. I will invent terrific stories for as many items as possible with extra emphasis on those that were hard to come by. Even if a thing is ugly or near useless or both the fact that it is rare or anyway they scored it from me being quite the legend makes it to die for.

Ideally without the dying part.

CONTRACT
Crew of t
Mermaid

DAY 13

Very shrewd. I'm almost impressed.
I thought so.

Shores of Plenty

You wouldnt want to settle down anywhere on this sea but if you did it might
well be here. This old place has only recently broke free of the Devil's Shroud but
its now a beautiful spot attracting the friendly kinds of people we like. Maybe we
can pick up something useful from a traders little shack and try things on for size
under the perfect blue sky. It could all be trash but dont blame me. I dont think it
will be trash though and we should push for a good price because you know people
here tend to be in a good mood. At least until they realise there are still things
around that want to eat you.

Ancient Isles

All those words I wrote down about the merfolk hideout being impressive and kind of beautiful were true but that place has nothing on the islands in this place. I dont know who used to live here but I know that they werent pirates. They built huge temples out of slabs of stone or sometimes just carved a cave into what they needed and you can see their paintings and markings still. When pirates came here they learned some of the old ways like how to curse a chest or a coin stuff no-one wrote down I guess so now it's gone...

Ha! That went so much better than I couldve imagined and I imagined something pretty great

So, we are never allowed back is what you're saying?

Yes. I mean no. Thats right.

The Wilds

If it wasnt for the treasure this place would be deserted I guarantee it Nura. But hey guess what it is about the treasure so yes we are going. But we are leaving just as fast. Make a list. I suppose you would be suspicious too if pirates from miles around were dropping by saying Hey good to see you ... when it isnt. And we love the place... which nobody does. And only to get their hands on whats left of the goods in the wake of that big battle. Which is exactly what we are doing I know but I think we are more honest than mostor try to be.

That's right Bel, we were honest(ly trying to rob them blind)

You dare to trample on my feelings and question my honor?

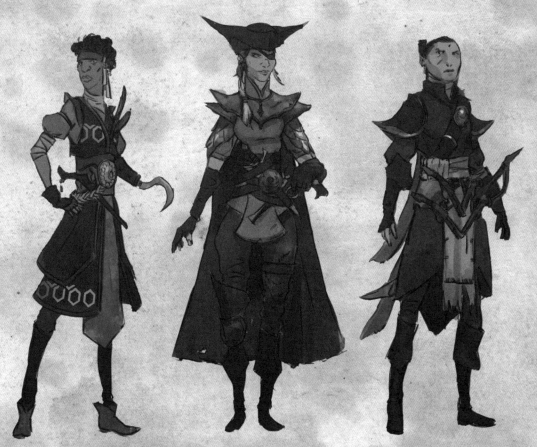

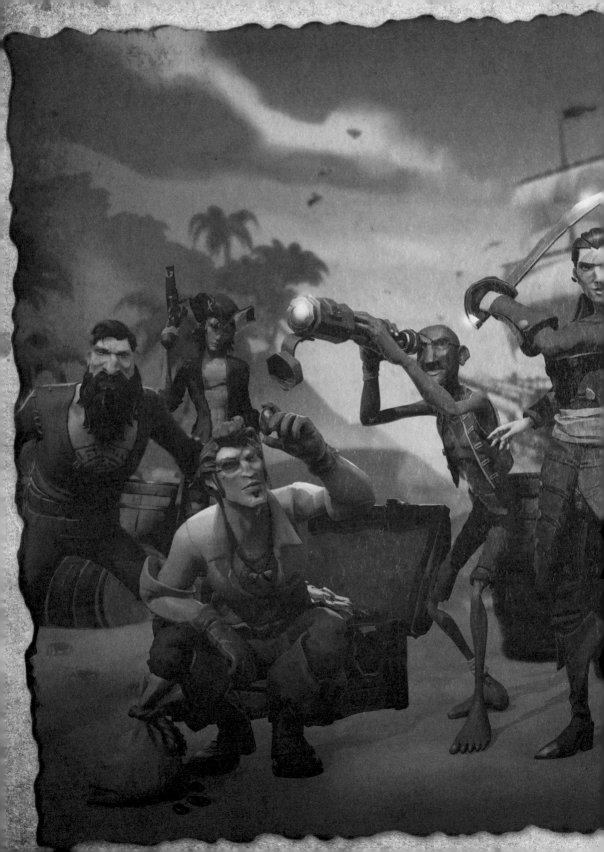

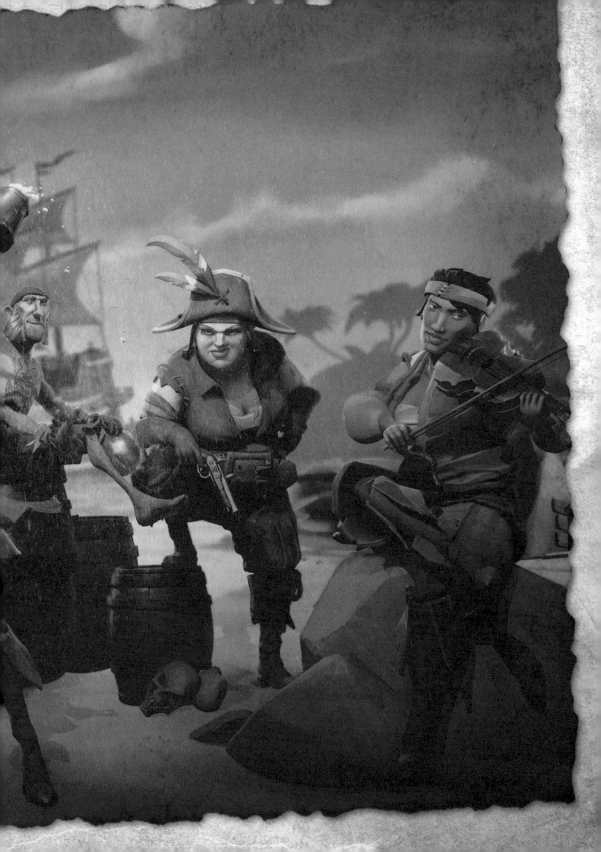

DAY 16

We can feel proud of her Nura. Our ship the whole crew. Me and you. The Plundered Crown.

It was our chosen name from out of nowhere oddly just like that the day we were married. Well... not actually out of nowhere. I don't think I ever told you this before Nura but this book... it sucks the secrets out of you through your quill and holds them. Feels like confessing. I didnt want to spoil our day.

I know I never mention Mum but the first time my Dad saw her he was surrounded by his crew in a tavern with a chest hed salvaged spilling its gold and gems across the bar. He was playing his fiddle and she danced right on up to him and just for a joke he reached into the chest and placed a golden crown from who knows where on her head. And she laughed and he kept playing and she kept dancing and before long it was just the two of them in that tavern and you can guess what happened next Im sure.

When it was dark and time to come back aboard Id hear Dads music coming from the dock and Id tug on your arm until you put down whoever you were fighting and came home with me. And as we got close Id see her in the Captains Cabin as a shadow in the candle light and shed be dancing with that crown on her head. His Pirate Queen.

Of course Mum left and Dad has his own little ship far away from here but the *The Plundered Crown* is still here for me when we are coming back from adventures. Keeping us all safe. Of course we keep each other safe too.

That works because we have good people. Sometimes I choose them. A lot of the time they choose us. Because of how you run things Nura people trust this ship. I will sure notice if something isnt going down well with the crew and can usually turn things around there.

The cursed chest is causing some of the jitters on board but I think that once we leave the port under fresh sails with bellies full our crew will settle themselves. For you to have everything in its place when so much is being swapped out and rearranged must seem almost impossible.

We just never talk like that though. How did I get so serious? We are doing the right thing. This is our truth.

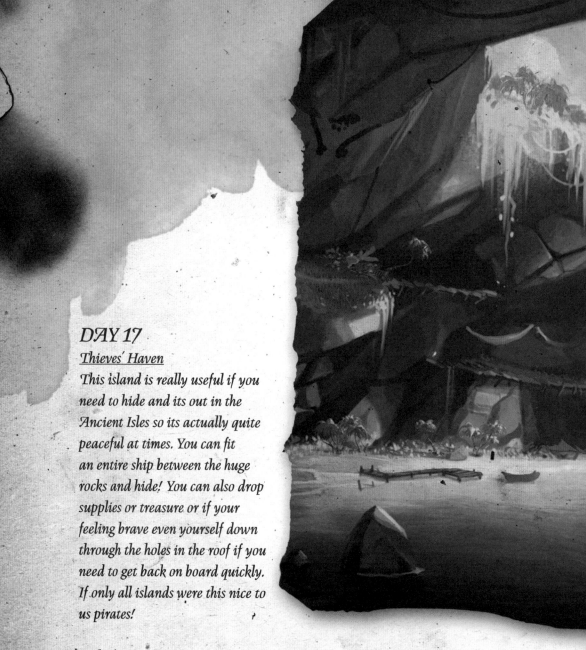

DAY 17

Thieves' Haven

This island is really useful if you
need to hide and its out in the
Ancient Isles so its actually quite
peaceful at times. You can fit
an entire ship between the huge
rocks and hide! You can also drop
supplies or treasure or if your
feeling brave even yourself down
through the holes in the roof if you
need to get back on board quickly.
If only all islands were this nice to
us pirates!

Sailor's Bounty

At first glance this just looks like another patch of sand somewhere youd stop to get
some fruit maybe or take a break but nothing else to it. That was until our tenth
summer Nura and I decided to go explore the sinkhole in the middle of the island
and oh the caves we found. Stretching on what felt like forever. So lucky we didnt
get lost but when youre kids you never stop to think about that stuff.

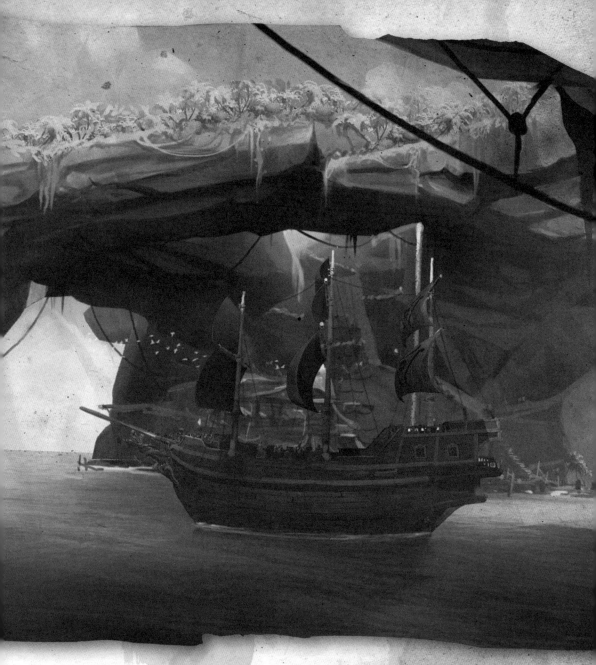

Shipwreck Bay

Its not unusual to see wrecks in The Wilds because those rocks can be nasty and the storms will really ruin your day. But the wreck here is HUGE! If you are feeling brave you can climb the mast to reach the upper part of the island but every time I go back the mast feels more slimy and more rotten to the touch. Maybe I can use a cannon to get up there...

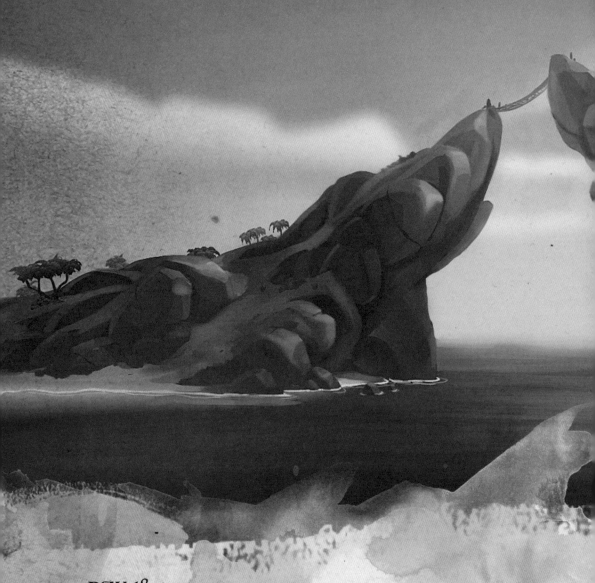

DAY 18

Devil's Ridge

I suppose most people never look past the big rock outcropping and think "oh sure
lets have some grog and then some more grog and then jump off", but if you take the
time to look around theres this cave system that reaches really far back and inside...
PIG! Well a wild boar like some weird shrine to boars. A huge skull and cave
paintings just on walls everywhere. Did they really worship a boar or was someone
just hungry?

Smugglers' Bay
This place just goes to show you not everywhere in the Shores of Plenty is sunshine and smiles I mean the island is pretty enough and the big horseshoe shape makes a good bay to shelter from storms... its just the people you find here are not the kind of people even most pirates want to mess with. Unless you have some merchant cargo that isnt yours that is.

DAY 19

Smugglers!!! Forget everything else I said in this book until I can go back and scribble it out but they are just the worst and will regret ruffling your hair. Yes I am still furious but now that we are not choking on gunpowder smoke and stepping over swords and spilled grog I have realized something.

Flameheart used this book like a journal so I guess I will too. Memories fade and I want this anger to stay fresh forever. We had dropped anchor at another outpost and I was trying to find someone anyone to take the merfolk chest for a good price. Never a mad old woman around when you need one ehh?

When I got back to the ship it was to see you and Jean along with some guys in fancy breeches and those silly shirts that look like white roses. Oh and boxes. So many boxes of silk and wood and even a few paintings.

Well you know I hate the thought of an honest days work but you Nura insisted. Of course a cargo run always makes you a target but with our shiny new guns and a hold full of ammunition you we thought no one would be stupid enough to attack us.

Two against one doesnt seem so stupid I guess. Not sure why they were working together (probably gold, its always gold) but we had barely let our sails down when the first shot went over our heads.

Someone got jittery but that was all the warning we had. With our hold full we were never going to outrun them and if they caught us between them wed be swimming home for sure. Lucky you and I dont need words to know what the other will do. As the nearest ship drew alongside you were already dropping the anchor and I was pulling on the wheel with all my strength.

The Crown screamed but held together and our nice new steel prow swept across their deck sending them every which way and even into the water. By the time they were on their feet you and I had sprinted up the length of our ship and down onto theirs with our swords and muskets saying hello. I remember seeing the name plaque as I bashed some guys head off it and it think it was *The Salty Hippo* or some other fat animal.

By then of course the second ship had turned its cannons to face us but by then the *Hippo* was ours and we put its cannons to work. Maybe they thought they'd been betrayed but the other ship turned its cannons on us and we shot each other to splinters while the *Crown* barely got scratched. Sorry little hippo but down to the sea bed you go. By the time we abandoned her and came home the other ship was limping off out of ammo and looking like she'd tip any minute. Thats what you get!

Of course we were in no mood to spare the crew their turn in the Sea of the Damned but as I pulled their captain off the ladder ready to break his nose he looked me in the eye and said "I know about the chest." Just like we had known each other for years.

His name is Cole and now he is nursing his wounds in our jail below.

 Nicely told dear. I found you asleep with your head on this page.

 I cant believe you wrote that down!!

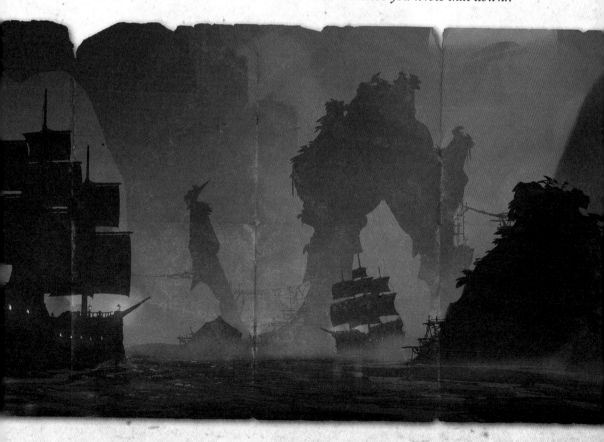

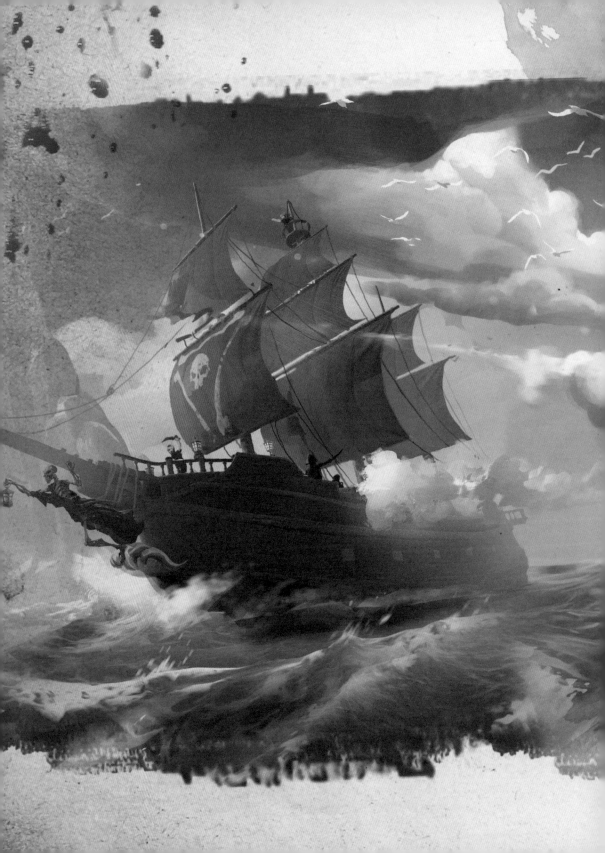

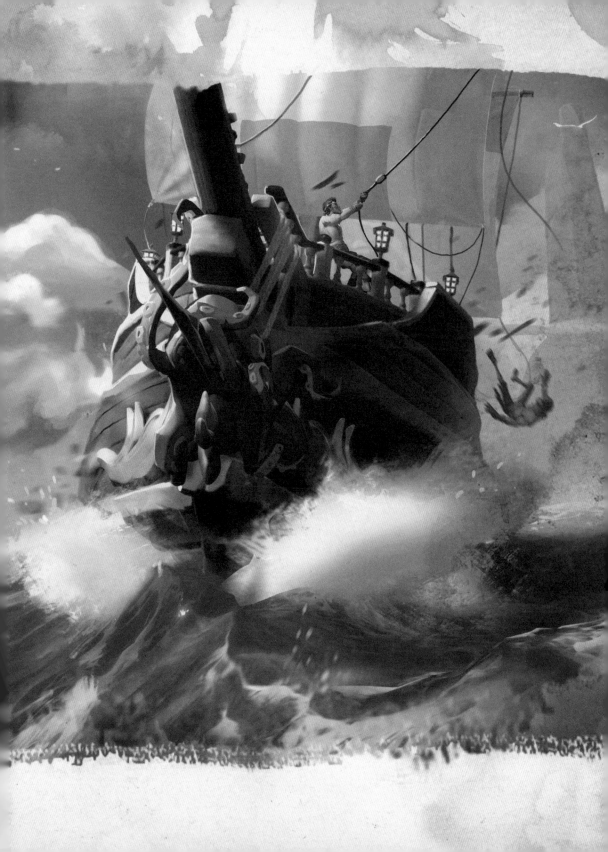

I dont trust Cole Nura. Not one bit. But the man can talk your ear off and I am too busy and too angry to listen to it all. So here is his little life story for the book. See if you believe it.

DAY 20

"My name is Cole, or at least that is how I prefer to be known. When people say 'his heart is as black as Cole', you may rest assured that they're referring to me, for there is no greater villain, no more devious a vagabond than I!

"Your gracious Captain Bel has spoken to me at length, though perhaps shouted would be a better way of putting it, about the luckless Flameheart and his crew. I took pains to explain, using all of the wit and perspicacity I possess, that I could not possibly have had anything to do with the roguish attack (so diligently recorded in these pages) upon his vessel, for I was but a twinkle in my father's eye when it happened. Yes, I'm afraid Old Flameheart has been tottering on skeletal feet for quite some years since his final diary entry.

"His crew were one of many employed by my patron over the years with the aim of retrieving that chest, and they were also the first to succeed in digging the wretched thing up... only to lose it at the bottom of the sea. Imagine my patron's delight, then, when random chance should lead him to overhear Nura and Bel discussing, in very heated tones, what could only be the chest he'd long considered lost.

"Quite why my patron chose to take the chest from you by force rather than simply engaging in a trade is, frankly, of little interest to me. I consider it a point of personal pride never to waste time with such trifling concerns, for I am a proud representative of the group known as The Twisted Knife. Doubtless you've heard the name before, spoken in hushed and fearful tones over the flickering candles of some squalid drinking den.

"We of the Twisted Knife have a simple creed: we hunt down and sink pirates in exchange for money. Normally there's some measure of violence involved, though in this case my patron cared very little what fate befell you just so long as that strange, whispering chest found its way into his grasp.

"Has the chest whispered to you yet? If not, it can only be a matter of time. Still, since I have been bested in battle and find myself rather at your mercy, I will be more than happy to guide you to my patron's den where you may shove the treasure down his gullet for all I care. What I desire now is my freedom, and a ship to command..."

So now we know Nura. Yea now we know. Some rich coward sending suckers like Faintheart out on a fools errand to bring home a cursed chest. Part of me wants to cut this guy to pieces and part of me wants to know how much we can take from him in trade for his precious box. *We could do both. I'm joking of course. We have a code of honour even if he doesn't.*

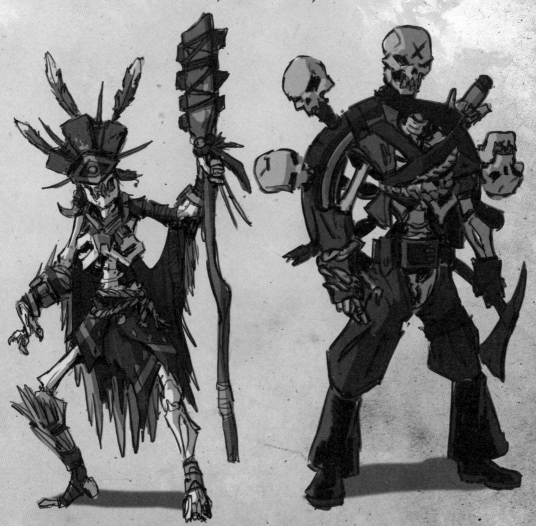

DAY 21

For the first time in a long time I really dont know what to do.

If we try to keep the chest or even if we don't the Twisted Knife guys are just gonna keep coming Cole says and for once I think I believe him. What if next time its three against one? Were tough but not invincible.

Oh yeah when I went down to the hold earlier Coles cell door was not locked! Jean forgot to close it properly when he took him his food! I hit him but what else can you do? He acts like a puppy around our prisoner.

I need to make a choice even if its the wrong one. Even Flameheart managed that.

DAY 22

We are going to find this guy and give him his chest.

DAY 23

Cole has spent the day above deck so he can help us navigate to the island cove his patron operates out of. Even rich guys need a hideout from time to time it seems.

DAY 24

Still sailing. The mood on the ship is tense and so am I.

Last night Nura... Last night while you were on watch and I was thumbing through the sketches you added to this book... The chest whispered to me. And worse still...

~~You know how when you stare at a cloud and suddenly it looks like a person or a rabbit or some other thing...~~ No actually its more like when you look at something that was comforting and familiar and suddenly you see a pattern in there you never noticed before. Its still the same thing but different.

There was a face on the chest or inside it somehow like the surface was made of broken glass and it was moving around on the other side somehow. Scared me half to death and of course I went for my gun but what was I going to do shoot a box?

I couldnt understand the words it whispered but the worst part is Im not sure they were meant for me anyway.

DAY 25
Did someone shout Kraken?

They did.

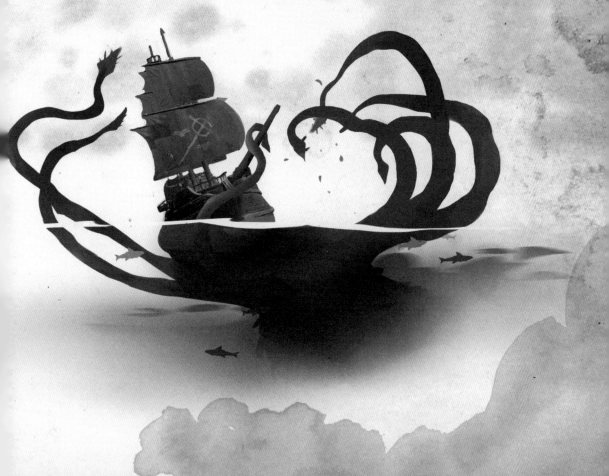

DAY 26
Kraken!

Terror had gripped the crew but that was a good thing... terror makes you move. If the beast were not keen on having a fight it wouldve been long gone. And all that fear was because we could sense its presence deep below but dangerously close by.

It had been first sighted from the crows nest dragging another ship to its doom. Judging by the size of the ship and distance between us we could tell it was large enough to enjoy wrecking us too.

On any other day I wouldve ordered immediate evasive action but this was the answer we were looking for. A good solid challenge to bring us all together? Nothing else would do but to wrestle with it!

Normally pirates would band together in their ships to even think about taking on a kraken but I was still cocky from our fight with the Twisted Knife and besides I had spotted something in the darkness. Three cannons on a high cliff.

Beb, If ever we are parted this is how I will remember you. This is who you are.

Dont ever think like that Nura. This entire fight happened without time to think we just had to act and the rest was instinct and shades of that other feeling that I really hate now.

But thank you.

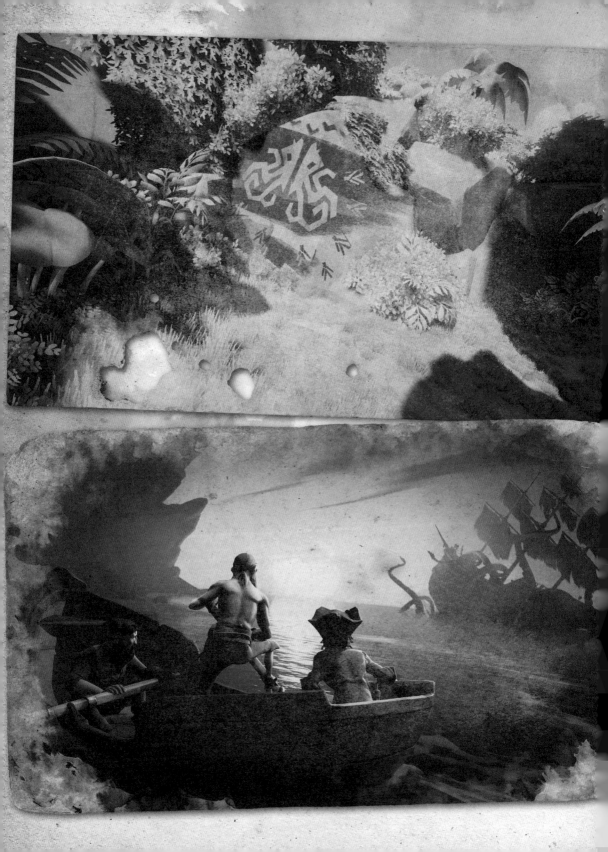

If we sailed the Crown in close enough I could jump from the crows nest and lure it away from our ship, maybe even wound it before those tentacles slapped me silly. I'd probably get my first look at the Sea of the Damned but Nura would come find me. She always does.

As things turned out it didnt get that far. That damn chest had other plans.

There was a feeling that grew from the familiar fight or flight but swiftly became paralyzing. We looked to each other wondering if it was our own issue to deal with but it was all of us and within seconds we were brought to our knees as one. The whispering evil voice that I recognized grew so loud that it was all I could hear. Through darkening vision I saw the Kraken curl itself around the ship as we were violently rocked. Something invisible was coiling around me too.

Had you not beaten me to it Nura I know this would have been our end. I do recall making it to the cabin but who knows with how much time and strength to do exactly as you decided.

Whatever was in the chest we will never know for sure. But remembering how it came alive near water and wondering why a kraken would come looking for us to begin with... it just made sense that the kraken would at least react to it moving away. Was the chest itself calling out to it? Like a kraken whistle? That'd be a crazy prize for some rich idiots mantelpiece.

All I know for sure is as soon as it splashed down in the distance the creature let us free. You know what I dont give a crap if that was how it was supposed to go. I can barely sit straight to write...

Can I still walk? I can still walk.

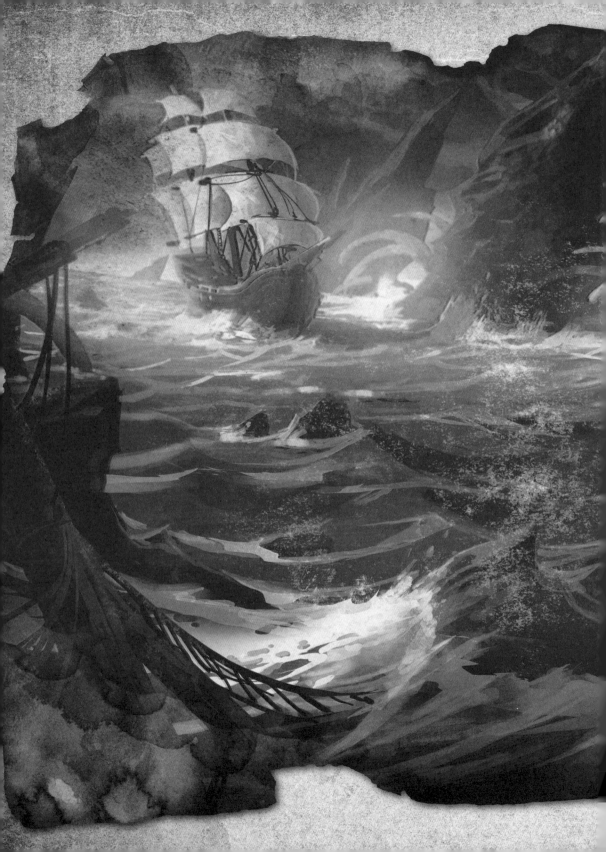

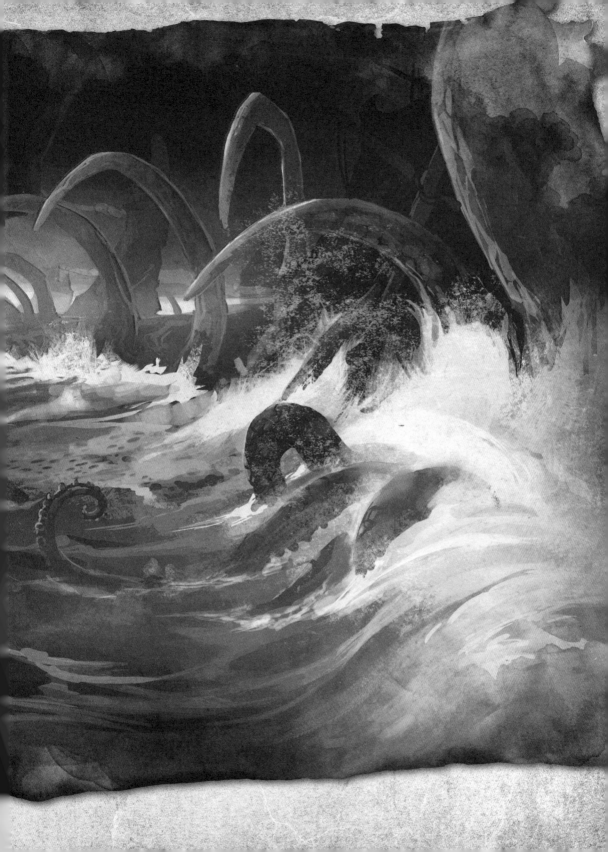

DAY 27

We are a broken ship.

Rough guess Id say we lost a third of our supplies and those of us that are left are absent too. You know hardly even there behind the eyes just dealing with the shock kinda thing.

We are a small crew and short handed so Ive assigned Cole to look for anything that can be salvaged from the merchant ship that sank near by even if its just more buckets for bailing out water and then we can limp back to port.

Cole has been gone for far too long. Hes either dead or fled like a coward. But I need to know which so I sent Nura to go find him. Nobody has challenged me which is a little odd. Or it could be that I look so defeated that they cant bring themselves to make things any worse. And still looking to me for answers.

This is not what I thought it would be like to finally get rid of the chest Nura. No mermaids singing a victory song or anything haha! No bright gleaming mermen flipping somersaults in celebration as jewels rain from the clouds because the curse is lifted. Nope.

Nura and Cole came back with a few barrels of food and supplies that were still dry so we can eat tonight. Cole is in the galley with Jean now. Good to see him giving a helping hand and fitting in. As usual it is Nura and I that will be served last. Today we will all eat on deck however. We should all eat together then maybe it will make talking easier.

Before eating I made what I thought was a damn fine speech about the challenges we have faced and how proud I was of everyone. As I spoke I looked into everyones faces to let them know how much our lives on this ship mattered and steps we can take to rebuild.

Jean has slipped below to the galley bless his soul. I asked for what we had left of the wine to be shared. The guys are waiting for us to eat so I should stop writing now. Maybe it will be okay.

Sleepy.

DAY 28

Cole drugged us. Poisoned us. Whatever. And then he filled the ship with his mates from the Twisted Knife while we were out. Guess now I know why he took so long yesterday. I will drown him with my bare hands Nura I swear it.

Looks like the others didnt even try to stop him. Nura is outside with them and I am locked inside our cabin. Occasionally there is the sound of a dunking but no laughter only jeering.

So its mutiny? Is this supposed to be a game?

We are outnumbered but I will not stand by while they hurt a hair on your head Nura. Our crew stopped trusting us and the blame for that must fall to me but we will always have each other. I dont even hope it, I know it. Deep down.

...someone coming.

Cole wants to take the ship as his own. He will have us walk the plank or feed us to the sharks or both. It won't prove anything. But I will not go quietly.

Right now all I can feel is cold anger in me colder than the blades in my hands as I prepare for the fight. Later after I talk to the Ghost Ship captain and bargain my way through his door there will be time to be sad but it wont be for long.

Thats the thing about this place. This world this life. Maybe we will wake up on an outpost with the sun shining down and a ship with our name on it floating by the dock. Or maybe itll be the dead of night in a raging storm and we will sit in the tavern and laugh about how we died and drink and swear to find the cowards who did this and take back the Plundered Crown.

Not every voyage will go to plan. Days like today can go so sour. But when we raise the anchor Nura and we stare at the horizon at all the places we can go... when we talk about all the things that can happen and that no one can tell us what to do, not ever.

Thats freedom plain and simple. Its why we are out here. Only when your completely free can you discover who you really are. Even Flameheart knew the truth of that.

My swords are sharp. My guns are loaded. My teeth are bared. I have all the best rude words in my head (sorry).

Goodbye Nura. There will be hugs when we return.

I asked around at the Old Sea Dog and some of the regulars reckon that chest had a summoning spell on it, that was what brought that kraken down on us.

Mm, quite the detective-pirate, aren't you?

Well someone's got to use their noggin to find out what happened.

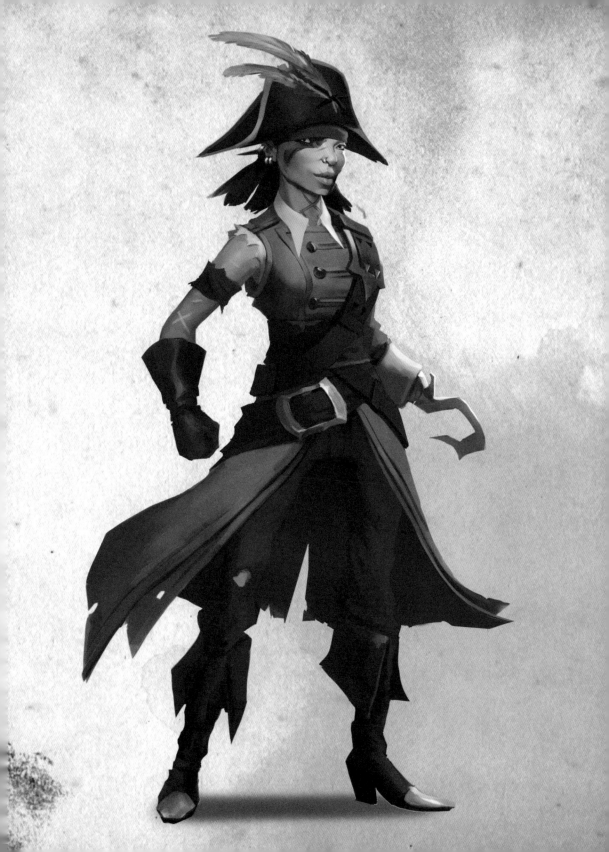

THE APOLIGY YOU WANTID

Deer capin Bel,

I am so sorry for lettin coll tak yor ship. I am sorry for poisnin everywun but you and Nura espeshly. And I saw in yor eys when you gav me this book that just sayin sorry is not enuff for you to not run a sowrd thru me wen you com bak for this ship. I ow you an esplinashun.

I heer they kild Nura anyway. They were goin to kil you if I didnt agree to help. They trikd me into helpin. See they didnt kil you just like they promisd. I didnt see that they cud be so low. I dont no who to feer most now betwin you and Nura. She wil com bak for you capin.

I am not sory just for my life. I am so sory that I wud take it maiself aniway but this is the second time that you hav trustid me wen nobody els wud.

I wud stil be servin disapontin dishis to drunks in the drownd rat if you hadnt recognisd me. I mean if you hadnt reely seen me. If you hadnt reely tastid my food and understud.

Of cors I wil help you capin. I wish I new how rite now.

Jean

Among the things Jean is good at, standing up to scumbags isn't one of them. Not sure if I can face him again, I'm sorry Bel. Anyway, you hired him. Or your stomach did.

Well as we are here writing about it instead of talking about it you know in person I should probably say write this Nura. It wasnt Jean that killed you it was them. They had the lad over a barrel threatening who knows what was to happen to me if he didnt do what they asked. I mean they could have killed me too I know but that coward wanted me to suffer the worst thing imaginable. And I did I saw you dead.

FULFILIN MEAT DISH

~~4 steaks about 1" thick~~ crew can hav rats wot we hav fatined on biscits

~~1 large onion~~ rasons

1 tsp. salt yes! But need moar than 1 tps ha ridlclus

~~Fresh grated horseradish~~ ? look it up or ask

~~1 Tbsp. shortening~~ sum lard I hav got

~~4 button mushrooms, cleaned and sliced~~ nope

~~2 Tbsp. Worcestershire sauce~~ vinigur

~~¼ cup water~~ fill pot with watuer

1 Smak rats to make them tenda and mash ther bons a bit
2 Slise into tenda strips
3 Soak in lard
4 Burn on coals turning frikwently
5 Add salt lots of it
6 Sprinkul with vinigur
7 Add rasons and serv

Jeans Leftova Speshul

Eggs if weve got em
Meat (goat or pig or crab or shark)
Salt (for meat)
Pees
Rasons
Biscits

This resipe is in case crew is complanin and Capin says to do somthin cwik
1 chop meat into peesis enuf to go round the tabul so no fitin over it
2 Soke in wine and rost in ovin for 15 minits or so
3 Boil pees and soke rasons to mak them a bit bigur than uswal
4 Hard boil eggs and let evrithin dry off befor servin
5 Serv with biscits

TRUTLE SUP

1 1/2 sticks butter *lard*
1 pound turtle meat *bigist ones we can cach of corse*
Salt and freshly-cracked pepper
2 onions, diced *rasons*
6 stalks celery, diced *pees*
30 cloves garlic, minced *beer cud work?*
3 bell peppers, diced *shud by ok with just the pees*
1 tablespoon dried thyme, ground *flour for suprisin tekschur*

1 Melt lard and cook meat first until its dark.. ...then add salt
2 Stir with beer for 20 minits until all dride up
3 Add moar beer and pees and keep stirin for 20 minits
4 Boil in water for haf an hour probly
5 Drop moar beer (or vinigur) and cook 20 minits
6 Stir cook and tast evry now and agin until alrite for eatin

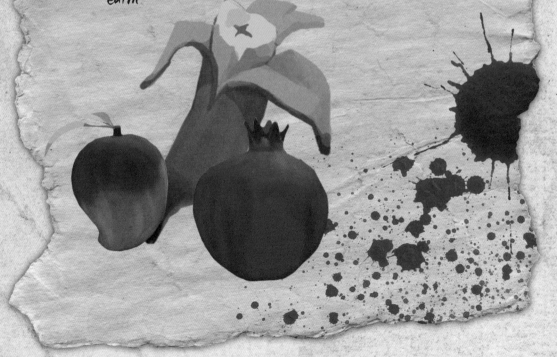

SUM THINGS ABOWT COLL

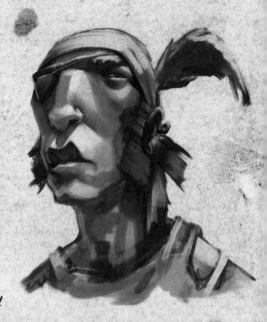

Deer Capin Bel,

Becos I am just the cook Coll and his men dont
bother me unless ther belees ar emty.

If Coll had only haf yor intelijuns capin he wud
see nobody deesint enjoys workin for him

It is greed or feer.

He has 2 gards Soapy Samson and Knock-knee
Norris to do fitin for him and they are wel traned
and wel pade.

If you can tak them down 1st Coll wud not hav aniwun left wiling to fite for him it
is as simpul as that capin. You wont be abel to do this on your own tho. I dont no
how to fite becos I hav never wanted to but I am strong and I can get in the way.

Coll is scared tho capin. He has been scared eva sinse he sent you to the see of the
damt.

Unfotunatly ther is one of the men wachin me at al tims in the galy to mak sur I
dont put anythin funy in ther food. I wudnt do that aniway. Wen ther time is up I
want them to feel it.

I am very gud at hidin my feelins as you know capin.

They wont see you comin.

They wont see me smilin.

Jean

Bosun Bill

Bosun Bill was known throughout the port
A truly dreadful pirate who was always
 getting caught
Not one scheme for stealing could he
 hatch
'cause someone would spot
The treasure he'd got
And Bill they'd snatch!

One day Bill awoke lying on a distant
 beach
The last of his grog was just out of reach
He groped around with trembling hands
And struck something in the sand!

He'd stumbled upon a part
Of an ancient chart
Stained and torn, the old map told
The way to find a stash of buried gold,
 so...

Bosun Bill set out to find a crew
But everyone he asked replied "I'll never
 sail with you!"
'Til at last, he plied a man with ale
To lend him his craft,
A rickety raft
Then Bill set sail!

All by himself, Bill trembled in the dark
He lost both his boots and hat to a shark
He followed the chart 'til at last he saw
The gleam of a far-off shore.

The trail led into a cave
Silent as the grave
Bill stood gaping at what he saw
A hoard of treasure piled from roof to
 floor.

Bosun Bill stuffed treasure into his sack
He loaded up the boat, but he heard a
 mighty crack.
He'd taken too much plunder when he
 should have kept it light
The raft and all the gold sank out of
 sight.

Bosun Bill let out a terrible curse
He'd had a chance at glory but he'd only
 come out worse!
To this day, he's trapped on the island
 still
Not very clever,
Worst pirate ever,
It's Booo... Sun.... Bill!

Grogg Mayles

There's a tale of old the sea dogs told
'bout the most fearsome marauder.
He was such a brute, he'd nick all your
 loot
Then he'd sail off with your daughter.

Who's this loathsome rat, ye say,
Who sailed the seven seas?
He'd take on all the merchant ships
And bring them to their knees.

Grogg Mayles! Grogg Mayles!
Black hearted to the core.
Grogg Mayles! Grogg Mayles!
The gold he did adore.

With a hand on the wheel and the
 other on his sword
You'd get strung up if you glanced at
 his hoard.
Yes he was properly 'ard as nails and
 they called him
Grogg Mayles.

Now I get the feelin' you're not hearin'
How frightening he would be!
He could skin your chest right through
 your vest
While he cutlassed off your knees.

He'd plough his ship through storm and
 sea
No other pirate dared.
He'd plunder all the lubber's loot,
No treasure chest was spared!

Grogg Mayles! Grogg Mayles!
Black hearted to the core.
Grogg Mayles! Grogg Mayles!
Pirate provocateur.

Now is he dead? 'Cos we're not sure.
I thought I saw him at the tavern next
 door.
Yes he is rather fond of ale
And they call him Grogory Mayles!

We Shall Sail Together

Cloaked in folds of midnight waters
Side by side, we sons and daughters
We set forth for no king's orders
But we'll sail together.

Hold fast! Tides are turning.
Flames roar, fires are burning.
We'll all be returning
If we sail together.

All on the waves shall know our story,
Sing of the battles fought ashore, we
All shall thrive on fame and glory
When we sail together.

Words of warning have been spoken,
Ancient creatures have awoken.
Still, until our bond is broken,
We shall sail together!

Deer Capin Bel,
The mor I see Coll and how he handuls his cru the mor I no yor goin
to kik his ars.

I hav bin thinkin bak to som of the fites Iv seen yu win. There isntmani
yu lost. I dont think a krakin counz sins yu didnt reely loos it just ate
haff the ship.

OWR CRAZY CAPIN BEL!
Yuv ressuld to the grond evry new guy Ive seen com abord to prov
hoos capin. Som of them who didnt ask for it too. This provids grate
entirtanment for the ship!

Wons wen another ship tride to bord us yu tuk it on yorself to swing out onto thers and kik ther capin into the drink. His crew didnt feel like fitin much after seein that

I think we mitev had a fite over somthin wons erly on wen I 1st joind but I cant remember becos I was out cold befor I new wat was hapnin. I remember the hedake next day tho!

Wev herd yu and Nura shoutin at eech other but not seen anythin that looks like proper fitin other than the time Nura cast off leavin yu to chase after us swimin like a codfish for 6hrs!

Thats wy I wasnt suprise to find yu in my galy all dripin wet after the rest wer asleep. I was getin reddy for another sor jaw I must admit so I thankyu for nowin that I wud never let yu down that way agin. And I need to rite wat we talked about befor I forget wut the plan is.

PLAN FOR TOMOROW
I will now it is yu comin ther wont be any kweschin. Yu wudnt tel me how tho.

I am to act like I am scard out of my mind owin to yor return wons we all now its yu

Wen you ar abord I grab coll by the cote and beg him to sav me and this is yor kyu to deel with Soapy Samson and Knock-knee Norris.

I hav givin yu premishun to kik me into anee idyuts that stil feel like fitin yu as I am likely to flatin them and hopfuly not get skyuwad like a skwishi fish.

Ay capin I am redy to go.

GUD RIDANTS TO BAD RUBISH

I was stil sleepin below and herd the guys shoutin – some laughin. Thowt it was a wale at first becos it was the kind of cheerin that usuly meens some kind of sport. It was erly and still dark. My eyes were open but my hed was stil wakin up then I rememem new wat was happnin. It was hard not to smile capin after wat I saw.

We al new it was yu owin to the big sine yud lit on the mane sail that was burnin thru it.

** N **

And if I didnt now it was yu maiself I wuldv bin fritind too owin to that orribul nois comin from that massiv horn yu had sumwon blowin into and canons goin off.

Settin fire to yor sords like flambay was a fantastic idea capin. Im glad I cud help with that.

Paintin yorsel red including yor hare was sumthin I dont remember talkin about but grate!

It was like deth itself had com callin the twisty nife and his men took no chansis and jumped for ther lives. I tuk this as my kyu to start yellin an grabbin like we had pland.

And that is why you don't mess with pirates.

I want to write my side too, but Jean used up the last of the pages!

We would always needs more pages Nura.
Always more adventures to write about.

True. We'll just have to live them instead. Thanks book.

With only a sprinklin of foke left to defend cole his mane gards Soapy Samson and Knock-knee Norris pripard for yor arrival but wernt pripard for me going crazy. Also they went pripard for nura smashn into them a long wiv the canon bawl she wuz holdin so funee!

cole was yellin to his gards to get me off him as he was tryin to escape. A cowad like yu sed.

The hole thing came togethr almost exakly as y used too. Soapy Samson and Knock-knee Norris didnt now wich way to turn until yu wer alredy setin about them with burnin sords wild eyes and stiky hare.

I wotchd yu draggin cole to yor cabin by his hare after kikin the stuffin out of him.

Then I saw yu walk bak out yor cabin with Nura.
Boaf hoam at larst.

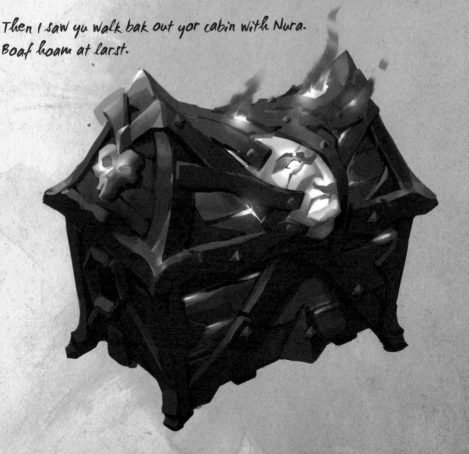

WRITTEN BY PAUL DAVIES

Paul has worked in gaming journalism for twenty years, writing and editing magazines and websites including *Official Nintendo* and *Computer & Video Games*. He is the author of several books, including *The Art of Assassin's Creed Syndicate*, *Awakening: The Art of Halo 4* and *The Art of Horizon Zero Dawn*.

TALES FROM THE SEA OF THIEVES
ISBN: 9781785654312

Published by Titan Books
A division of Titan Publishing Group Ltd.
144 Southwark St.
London
SE1 0UP

First edition: February 2018
10 9 8 7

Book design by Amazing15.com

To receive advance information, news, competitions, and exclusive offers online, please sign up for the Titan newsletter on our website: www.titanbooks.com

Did you enjoy this book? We love to hear from our readers. Please e-mail us at: readerfeedback@titanemail.com or write to Reader Feedback at the above address.

A CIP catalogue record for this title is available from the British Library.

Printed and bound in China.

Special thanks to Adam Park, Peter Hentze, Ryan Stevenson, Mike Chapman and the rest of the *Sea of Thieves* team. Additional content by Chris Allcock.

Additional thanks go to Bridie Roman, Paul Davies and Martin Stiff for their incredible work on this book.